SHROPSHIRE'S MILITARY HERITAGE

John Shipley

AMBERLEY

About the Author

Retired managing director John Shipley has lived in Bridgnorth, Shropshire, since emigrating from the Black Country in 1968, and is now an author and artist. He and his wife Kate have two sons and two grandsons.

An ardent season ticket-holding fan of Wolverhampton Wanderers FC, John has had two books published about the club, plus two about Nottingham Forest and one about Aston Villa. He is also the author of four Westerns written under the pen names of Jake Shipley and Jack Matthews. His book *The Little Book of Shropshire* was his first about his adopted county.

Shropshire's Military Heritage, John's twelfth book to be published, has allowed him to indulge his passion for military history.

Look out for John's next two books with Amberley Publishing: *50 Gems of Shropshire* and *Secret Shrewsbury*, both to be available from Amberley later in 2018.

First published 2018

Amberley Publishing
The Hill, Stroud
Gloucestershire, GL5 4EP

www.amberley-books.com

Copyright © John Shipley, 2018

Logo source material courtesy of Gerry van Tonder.

The right of John Shipley to be identified as the Author of this work has been asserted in accordance with the Copyrights, Designs and Patents Act 1988.

ISBN 978 1 4456 7809 2 (print)
ISBN 978 1 4456 7810 8 (ebook)

British Library Cataloguing in Publication Data.
A catalogue record for this book is available from the British Library.

Origination by Amberley Publishing.
Printed in Great Britain.

Contents

Map

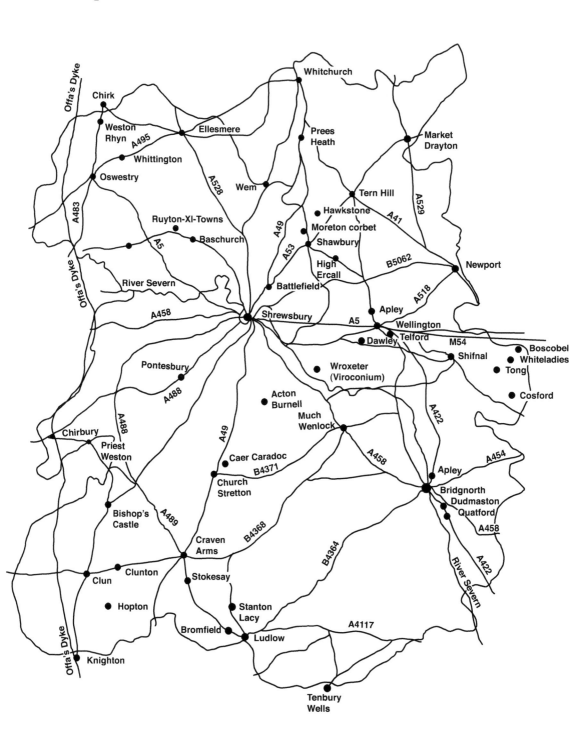

Introduction

The military heritage of Shropshire is among the richest in Britain. From the earliest times, through the Roman and Norman invasions, the many baronial disputes with the Crown, the Wars of the Roses, and the English Civil War, Shropshire's position on the England-Wales border has borne witness to a host of bloody conflicts. This disputed border country, known since medieval times as the Welsh Marches, is dotted with castles, and stretching along the county's western boundary and beyond is Offa's Dyke, a man-made barrier that once formed the border between England and Wales.

Shropshire's Military Heritage takes the reader on a journey through time, examining the impact of invasions and conquests on the county of Shropshire, including land battles, sieges and wars, local and foreign, paying respectful tribute to those brave soldiers who served and gave their lives in conflicts spanning the globe, such as the Peninsular War, the Boer War, the First and Second World Wars, and the Korean War.

From the 1700s Shropshire's military heritage has been intrinsically linked to the Shropshire Militia and other local volunteer units, plus the Shropshire Yeomanry, and of course the two regular Regiments of Foot – the 53rd and the 85th – and the various subsequent amalgamations that went on to form the King's Shropshire Light Infantry (KSLI).

Army designations are shown thus: 2nd/53rd and 2/53rd signify the 2nd Battalion of the 53rd Regiment of Foot; 1/KSLI signifies the 1st Battalion of the King's Shropshire Light Infantry.

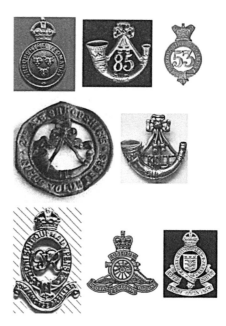

Shropshire's military badges.

1. History

A Brief Timeline of Shropshire's Martial History
AD 50
The Battle of Caer Caradoc.

c. 58
Roman Viroconium (Wroxeter) established as a Castrum for the Legio XIV Gemina, abandoned as a military post in AD 88.

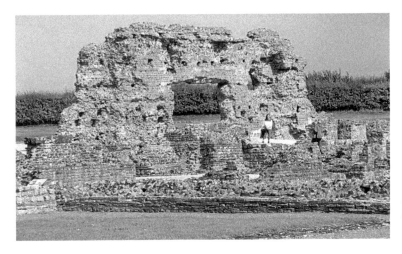

The Old Work,
Viroconium
(Wroxeter).

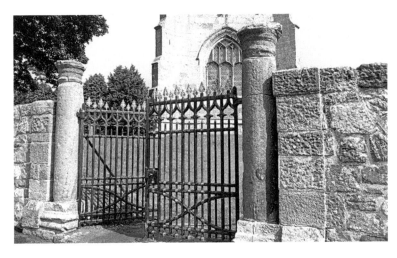

Roman pillars
from Viroconium,
now part of
the gates of
St Peter's Church,
Wroxeter.

584
A force of West Saxons sack and destroy Viroconium.

641/642
The Battle of Maserfield, near Oswestry. Penda, King of Mercia, defeats Oswald, King of Northumbria.

661
The Battle at Pontesbury (Posentesbyrig), near Shrewsbury. Wulfhere, King of Mercia, son of Penda, defeats Cenwalh (Kenwulf), King of Wessex.

Late Eight Century
Offa, King of Mercia, constructs the famous Offa's Dyke, located on part of Shropshire's border with Wales.

874
Danes destroy Much Wenlock Priory.

895–896
Danes march into what is now Shropshire, wintering at Quatford.

Sometime Between 900 and 925
The new shire of Scrobbesbyrig-scyre (Shropshire) is created as part of the defence of English Mercia against the Danes (also known as Vikings, Northmen, and Norsemen) who had settled eastern England.

912
King Alfred's daughter, Æthelflaed, Lady of Mercia, married to Æthelred, fortified Bridgnorth. Another fortification was erected at Chirbury in AD 913.

1066
The Battle of Hastings was fought on 14 October. King Harold was defeated by William, Duke of Normandy, who was crowned king of England on 25 December 1066. William subsequently makes his cousin Roger de Montgomerie (Montgomery) 1st Earl of Shrewsbury.

1403
The Battle of Shrewsbury. The first major battle in which English archers fought each other on their own soil, providing a brutal lesson in the effectiveness of the longbow in the hands of skilled exponents, which Henry V would use so effectively at the Battle of Agincourt in 1415. The Battle of Shrewsbury ended the Percy family's challenge to Henry IV.

1455–85
The Wars of the Roses. The fierce rivalry between the Houses of Lancaster and York plunged England into a series of civil wars. Lancastrian Henry VI is finally deposed and

Left: The Abbey Church of Saint Peter and Saint Paul, Shrewsbury, founded by Roger de Montgomerie.

Below: Ludlow Castle.

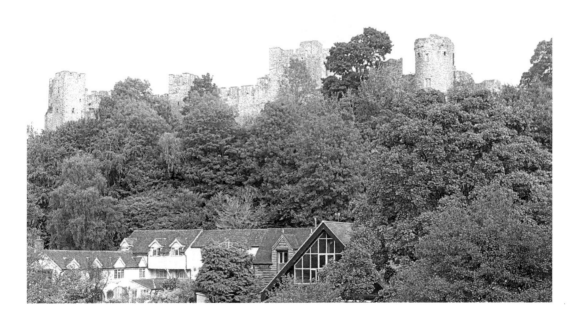

Henry Tudor House, Shrewsbury, where the future Henry VII stayed en route to the Battle of Bosworth.

Yorkist Edward IV ruled unchallenged until his death in 1483. Both his sons, Edward V and his younger brother Richard of Shrewsbury (the Princes in the Tower), are lodged in the tower and later disappear. The throne is offered to Edward V's uncle Richard, Duke of Gloucester (Richard III). Lancastrian Henry Tudor, Earl of Richmond (later Henry VII), is persuaded to challenge Richard III for the throne, landing in Wales in 1485, leading his Lancastrian army to Bosworth field where King Richard is killed, beginning the Tudor dynasty. Shrewsbury was the first English town entered by Henry Tudor and his army en route to do battle at Bosworth.

1642

At Nottingham on 22 August, Charles I raised his standard, travelling from there to Wellington, Shropshire, making the 'Wellington Declaration'. On 19 September Charles moved his flag to Shrewsbury where he was joined by his sons, Charles and James, and his cousin Prince Rupert. Charles remained in Shrewsbury until 12 October, then marched to Bridgnorth and from there to Edge Hill for the opening battle of the Civil War.

At the commencement of the first English Civil War in 1642 the majority of castles in Shropshire were garrisoned for the Royalist cause despite many being in ruins or in a state of disrepair. In August 1645, a Parliamentarian pamphlet listed the castles garrisoned by the Royalists: Bridgnorth, Broncroft, Caus, Dawley, Lee, Ludlow, Moreton Corbet, Oswestry, Rowton, Shrawardine, Stokesay, and Tong. Interestingly the list includes a number of fortified manor houses despite possessing limited defensive strength, and certainly not strong enough to resist cannon fire.

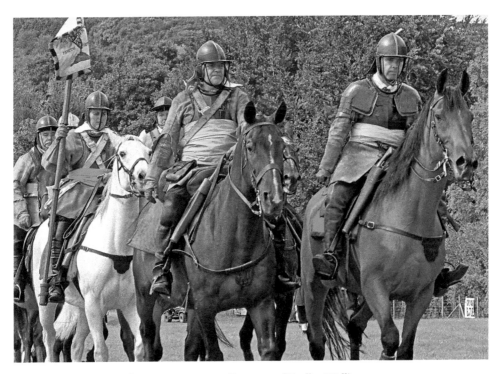

Roundhead cavalry, Civil War re-enactment. (Courtesy of Dudley Wall)

1643
On 11 September Parliamentarian forces led by Sir Thomas Myddleton of Chirk Castle and General Thomas Mytton of Halston Hall seize the Royalist stronghold of Wem. In October, Parliamentarian General Mytton defeats Lord Capel's Royalist attempt to retake the town.

1644
The siege of Hopton Castle was one of the bloodiest episodes of the English Civil War. In March 1644, Sir Michael Woodhouse, leading around 500 infantry and cavalry of Prince Rupert's Royalist army, besieged the castle. Opposing them were around thirty Parliamentarian defenders under the command of Samuel More. The siege lasted three weeks before on 13 March Samuel More agreed terms and surrendered to the Royalists. Various accounts regarding what happened subsequently are unclear; however, Samuel More swore that he alone of the defenders was spared, and that all the others were summarily killed and buried. Other versions claim that the Parliamentarians held out until the bailey was captured by the Royalists. Sir Michael Woodhouse decision not to grant the defenders quarter meant that prisoners would be killed. A popular theory is that the throats of the Parliamentary soldiers were cut, their bodies flung into the moat.

1644
The Siege of Oswestry, 22 June. Oswestry's castle and town walls were in such a poor state of repair that defence was almost impossible. The Royalist garrison comprised twenty gentlemen, plus around 200 officers and men. By noon the Earl of Denbigh's

Parliamentarians had captured St Oswald's Church, and the following morning the Royalists surrendered. On Saturday 29 June, Colonel Marrow led a Royalist counter-attack involving three days fierce hand-to-hand fighting in the town, during which the church was recaptured, but not the castle. A Parliamentary relief force under Sir Thomas Myddleton marched from Knutsford, forcing the Royalists to meet them in open battle at Felton Heath on 2 August. The Parliamentarians triumphed, subsequently rendering Oswestry Castle unserviceable for the next few years.

February 1645
Apley House, near Bridgnorth, is taken by Parliamentary forces under Sir John Price, capturing including Royalist's including Sir William and Sir Thomas Whitmore, and Sir Francis Oatley.

9 February 1645
Shrewsbury's Royalist garrison is surprised by Sir Thomas Mytton. In the attack the town's governor, Sir Michael Earnly, is killed, and sixty gentlemen plus 200 soldiers were taken prisoner.

10 June 1645
Stokesay Castle's Royalist garrison capitulates, and Sir William Croft is slain.

February 1646
Bridgnorth town and castle is besieged by Parliamentary forces, and following a month-long siege the Royalist garrison surrenders. The effects of the Civil War can be seen clearly at Bridgnorth. The leaning keep is a direct result of the castle being undermined and blown up by Parliamentary forces following the siege.

28 February 1646, and 9 July 1646 respectively
Royalist garrisons at High Ercall and Ludlow Castle are taken by Parliamentary forces.

30 January 1649
Charles I is executed.

September 1651
Following the Royalist defeat at the Battle of Worcester, Charles II and the Earl of Derby manage to evade capture and escaped north. Next day – 4 September – the fugitives reach White Ladies' Priory, sheltering there before moving to Boscobel House, where King Charles famously hid in a pollarded oak tree. Later he was taken to Moseley Old Hall, near Wolverhampton, just across the Shropshire border in Staffordshire.

December 1755
The 53rd Regiment of Foot raised in Shrewsbury by William Whitmore of Apley, initially as the 55th, renumbered the 53rd in 1756.

1756–1763
The 53rd serve in Gibraltar during the Seven Years' War.

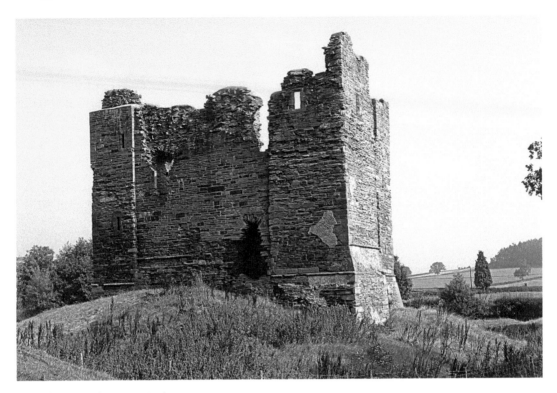

The ruins of Hopton Castle.

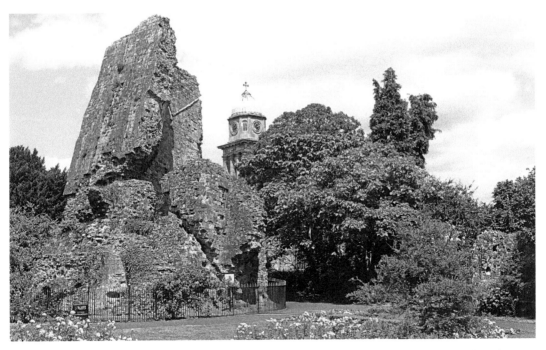

Bridgnorth Castle's Norman keep, leaning at an angle of 15 degrees – four times greater than the Leaning Tower of Pisa.

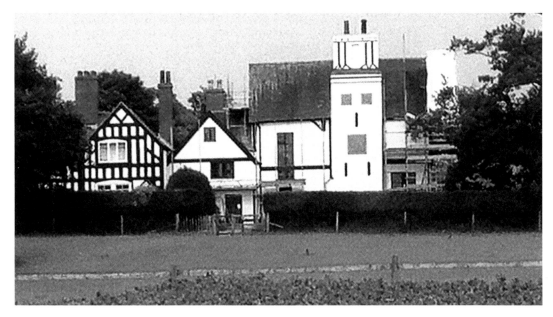

Boscobel House.

1759
The 85th Regiment of Foot raised in Shrewsbury by Colonel John Craufurd as 'The Royal Volontiers' (spelled with an 'o').

1761
The 85th take part in the Siege of Belle Isle, Brittany, during the Seven Years' War.

1762
The 85th take part in the campaign against Spain on the Portuguese border during the Seven Years' War.

1763
The 85th disbanded at Salisbury.

1776
The 53rd serve in the American Revolutionary War.

1779
The 85th Regiment of Foot reformed in London as the Westminster Volunteers by the Earl of Harrington and Lord Chesterfield.

1782
County designation was adopted and the 53rd was designated the Shropshire Regiment, becoming the 53rd (the Shropshire) Regiment of Foot. Henceforth recruitment was mainly from the county.

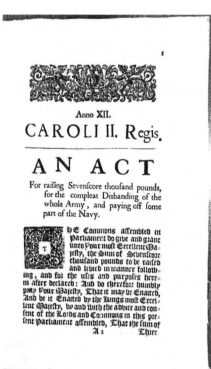

The Royal Oak Tree at Boscobel.

Army Disbandment Act, 25 April 1660.

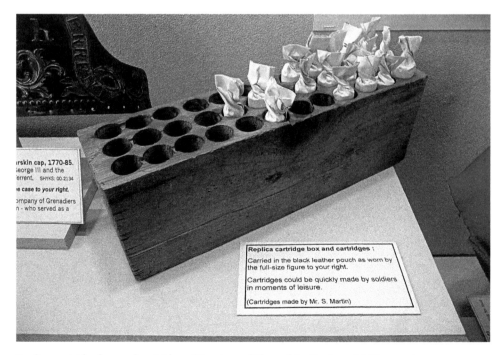

Replica cartridge box and cartridges. (Courtesy of Shropshire Regimental Museum)

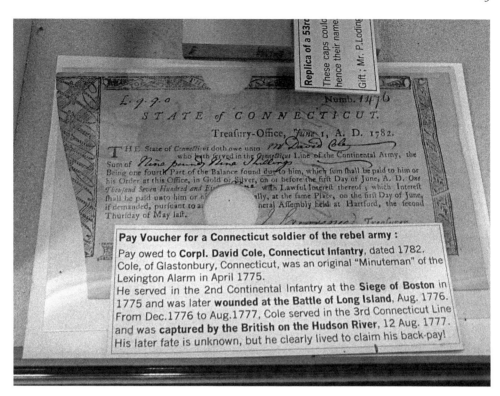

Within the display:

Pay Voucher for a Connecticut soldier of the rebel army :

Pay owed to **Corpl. David Cole, Connecticut Infantry**, dated 1782.
Cole, of Glastonbury, Connecticut, was an original "Minuteman" of the Lexington Alarm in April 1775.
He served in the 2nd Continental Infantry at the **Siege of Boston** in 1775 and was later **wounded at the Battle of Long Island**, Aug. 1776.
From Dec.1776 to Aug.1777, Cole served in the 3rd Connecticut Line and was **captured by the British on the Hudson River**, 12 Aug. 1777.
His later fate is unknown, but he clearly lived to claim his back-pay!

Above: Pay voucher for a Connecticut soldier of the rebel American army, 1782. (Courtesy of Shropshire Regimental Museum)

Right: Chapel bell from the ship *Ville de Paris*. (Courtesy of Shropshire Regimental Museum)

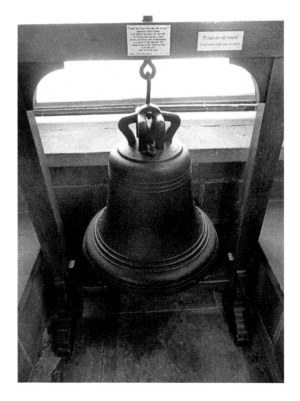

1782
Men of the 85th lost at sea off Newfoundland in the sinking of the Ville de Paris in a cyclone while homeward bound from Jamaica.

1783
The 85th disbanded at Dover Castle.

1793
The 85th reformed as the Bucks Volunteers.

1793–1794
The 53rd and the 85th serve in the Flanders Campaign.

1794–1795
The 85th serve in Holland and Germany during the French Revolutionary War.

1799
The 85th take part in the Anglo-Russian Invasion of Holland, fighting in the Battles of Alkmaar and Castricum.

1800
2nd Battalion is raised for the 85th.

1803
2nd Battalion is raised in Sunderland for the 53rd.

1805
The 1st/53rd sail to India, taking part in the storming of the fortress of Callinger, Allahbad, in February 1812.

1808
The 1st and 2nd Battalions of the 85th amalgamate; the 85th (Bucks Volunteers) convert to a Light Infantry Regiment.

1809
The 85th Regiment serve in the disastrous Walcheren Campaign.

1809
The 2nd/53rd sail to Portugal to serve in the Peninsular War, and were involved in the Battles of the Douro, Talavera, Bussaco, Fuentes de Oñoro, Salamanca, Vitoria, Pyrenees, and Toulouse.

1811
The 85th serve in the Peninsular War, fighting in the Battle of Fuentes de Oñoro and in the Siege of Badajoz in 1812, before returning home to recruit.

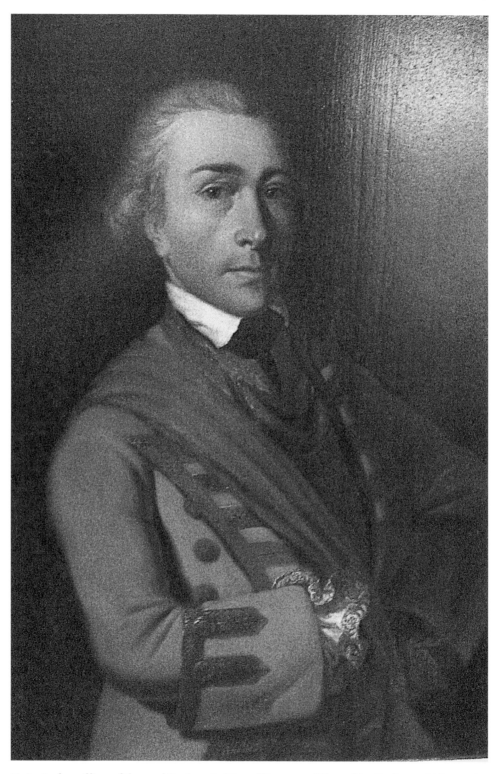

Portrait of an officer of the 53rd Regiment of Foot. (Courtesy of Shropshire Regimental Museum)

1813–14
The 85th return to the Iberian Peninsular, fighting at the Siege of San Sebastian, Spain, and in south-west France at Nivelle.

1814
The 85th serve in the War of 1812 in America, at Bladensburg, Washington, Baltimore and New Orleans.

1814–17
The 1/53rd serve in the Anglo-Nepalese War, were involved at the Battle of Nalapani, and during the Third Anglo-Maratha War.

1815
The 85th is restyled the 85th (Bucks Volunteers, Duke of York's Own Light Infantry) Regiment.

1815–17
After the Peninsular War the 2nd Battalion of the 53rd Foot remained in France carrying out garrison duties. The regiment took no part in the Battle of Waterloo in 1815. However, following the Emperor's capture, the 53rd Regiment of Foot was appointed to be Napoleon Bonaparte's guard on the Atlantic Island of St Helena, under the command of Lieutenant-Colonel George Ridout Bingham, where the regiment remained until returning to Britain in 1817. Following this the battalion is disbanded as part of the government decision to reduce the size of the British Army, resulting in the 53rd becoming a single battalion regiment again. Men from the redundant 2nd Battalion volunteered to serve in the 1st Battalion.

1821
The 85th restyled the 85th (Bucks Volunteers, the King's Light Infantry) Regiment.

1844–46
The 53rd serve in India during the First Sikh War (Sutlej Campaign).

1848–49
The 53rd serve in the Second Sikh War (Punjab Campaign).

1852
The 53rd serve on the north-west frontier, India.

1857–59
The 53rd serve in the Indian Mutiny.

1879–80
The 85th on campaign in the Second Afghan War (the Zaimusht Campaign).

1881

The Childers Reform restructuring infantry units. The 53rd became the 1st Battalion, King's Light Infantry. The 85th became the 2nd Battalion, King's Light Infantry. The King's Light Infantry renamed the Kings Shropshire Light Infantry (KSLI) in 1882.

1882

The 1st Battalion KSLI serves in the Anglo-Egyptian War.

1885–86

1/KSLI serve in East Sudan.

1894

1/KSLI in Hong Kong during an outbreak of bubonic plague.

1899–1902

2/KSLI serve in the Boer War (the Anglo-South African War).

1914–18

The First World War.

1939–45

The Second World War.

1951–52

The Korean War.

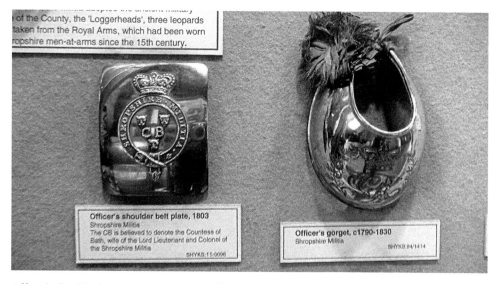

of the County, the 'Loggerheads', three leopards taken from the Royal Arms, which had been worn ropshire men-at-arms since the 15th century.

Officer's shoulder belt plate, 1803
Shropshire Militia
The CB is believed to denote the Countess of Bath, wife of the Lord Lieutenant and Colonel of the Shropshire Militia
SHYKS:11-0096

Officer's gorget, c1790-1830
Shropshire Militia
SHYKS:94/1414

Officer's shoulder belt plate, *c.* 1803, and officer's gorget, *c.* 1790–1830, Shropshire Militia. (Courtesy of Shropshire Regimental Museum)

2. Local Conflicts

Shropshire's key position on the turbulent border between England and Wales (known as the Welsh Marches) has seen multiple raids, battles and sieges over the centuries.

The Roman conquest of Britain began in earnest in AD 43 when Emperor Claudius decided to mount an invasion, appointing politician and general Aulus Plautius as governor of Britain, sending him from Gaul to subjugate the local tribes with four legions: the Legio II Augusta, Legio IX Hispana, Legio XIV Gemina, and Legio XX Valeria Victrix.

The Battle of Caer Caradoc, AD 50

According to Roman scribe Claudius Ptolemaeus, this battle was fought on the slopes and summit of a hill called Caer Caradoc.

Caratacus and Togodumnus, sons of the late king of the Catuvellauni, Cunobeline (Cymbeline), led a British force to meet the Roman army near Rochester and were defeated. Togodumnus died but Caratacus (Caradoc in Welsh) escaped and fled to South Wales where he persuaded the Silures tribe to join him in an attempt to push back the Roman invasion. He led them to Shropshire choosing Caer Caradoc hill as a good defensive position. The Roman army commanded by Pubius Ostorius Scapula triumphed, but Caratacus escaped, fleeing north to the lands of the Brigantes tribe, where he was captured and handed over to the Romans by Queen Cartimandua. He was transported to Rome and sentenced to death. The story goes that Emperor Claudius heard Caractacus' eloquent speech and spared his life.

The site of this battle is disputed. The popular belief is that it was fought near Church Stretton, but other contenders have been suggested. In Shropshire there is another hill called Caer Caradoc. There is also Briedden just across the county's north-west border, and there are those who claim it took place in the Malvern Hills.

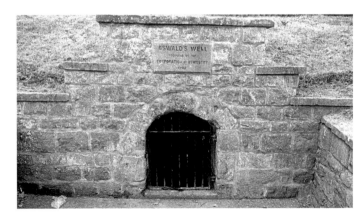

St Oswald's Well,
St Oswald's Lane,
Oswestry.

The Battle of Maserfield, 5 August AD 641/2

Oswald, Christian king of Northumbria, desiring greater control of lands south of the River Humber, led a strong force south into Mercia where his army was met near Oswestry by the combined army of Penda, pagan king of Mercia, and his Welsh ally, Cynddylan ap Cyndrwyn, King of Powys, and his men of Pengwern. Oswald was defeated and crucified. Legend has it that after the battle Penda ordered a sacrifice to the pagan god Woden, and the head and limbs of his dead opponent were thus severed from Oswald's body and hung on trees and stakes. The story goes that a swooping eagle snatched up one of Oswald's arms and dropped the limb at Cae Nef (Heaven Field), where a spring miraculously burst forth from the ground – that place is now known as Saint Oswald's Well, in Oswestry, i.e. Oswald's Tree (in Welsh, it's 'Oswallt', meaning Oswald's Cross). Oswald was subsequently venerated as a Christian martyr and saint.

The Battle of Pontesbury (Posentesbyrig), AD 661

King Wulfhere of the Northumbrian Saxons quarrelled with King Cenwalh (Kenwulf) of the Wessex, resulting in a great battle a few miles south-west of Shrewsbury. Legend has it that in this battle a great golden arrow was lost.

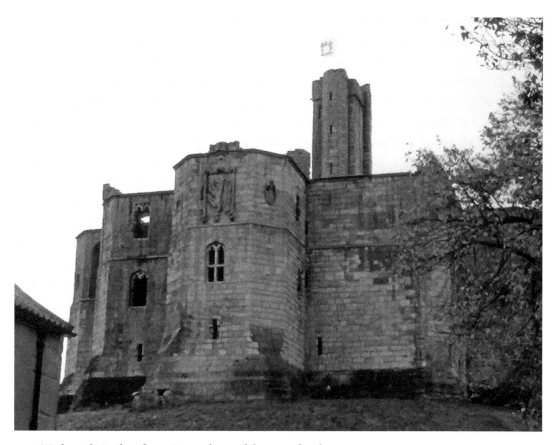

Warkworth Castle, a favourite residence of the Percy family.

The Battle of Shrewsbury, 21 July 1403

When Henry IV (Henry Bolingbroke, usurper of his cousin Richard II's crown) failed to repay the Percy family for financing and securing England's northern border, Sir Henry Percy's (Harry Hotspur) anger descended into full rebellion. The Percys (Hotspur and his father, the Earl of Northumberland) had supported Bolingbroke's own rebellion and imprisonment of the king in 1399. Matters came to a head in 1403 when the Percy's demand that the £20,000 debt be repaid was again ignored by the king. Additionally Hotspur hadn't been paid for the high office in Wales he'd been given by the king. The Percys now accused King Henry of the murder of Richard II, and of starving him to death in Pontefract Castle. This major falling out forced Hotspur to seek an alliance with his brother-in-law Edward Mortimer (Mortimer's claim to the throne was stronger than Bolingbroke's), and the Welsh patriot Owain Glyn Dwr (Owen Glendower), Mortimer's son-in-law. In July 1403 Hotspur marched south with 160 men to join forces with Glyn Dwr at Shrewsbury, and by 19 July Hotspur's army had increased to around 14,000 men. Hearing the news, Henry IV forced-marched his army to Shrewsbury to support the royal garrison there. The two armies faced each other near Harlscott, 3 miles north of Shrewsbury on 21 July. Unfortunately Glyn Dwr and his Welshmen did not arrive. Negotiations failed and a few hours before dusk, the king sent his men to the attack. When news that Hotspur had

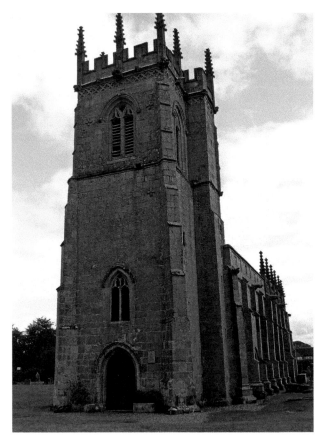

St Mary Magdalene Church,
Battlefield, Shrewsbury.

been killed spread through the rebel ranks all heart disappeared and by dusk most had fled the field. A church was established on the battlefield in 1409 as a memorial to the dead.

<p style="text-align:center">*</p>

During the Wars of the Roses Shropshire was divided in its support, with most of the land in the Welsh Marches being attached to the Duchy of York. The Duchy of Lancaster lands were mainly in Gloucestershire, North Wales and Cheshire.

The Battle of Ludford Bridge, 12 October 1459

The Earl of Salisbury led his Yorkist forces to Ludlow to join with Richard, Duke of York, and the Earl of Warwick. Their plan was to march to London via Worcester. Blocking their path was a much larger Lancastrian force led by Henry VI, leaving the Yorkists with no alternative but to retreat to Ludford Bridge on the outskirts of Ludlow. During the night of 11 October, Anthony Trollope, Captain of Calais, and 600 Yorkist soldiers switched to the Lancastrian side on the promise of the king's pardon. When they heard this bad news, York, Warwick and Salisbury crossed the river into Ludlow, claiming they needed refreshment. However, instead of seeking sustenance they abandoned their men and fled. The Duke of York, with his son Edmund, Earl of Rutland, fled into Wales. Salisbury, Warwick and York's second son Edward, Earl of March (later Edward VI), made for the West Country, and from there to Calais. At dawn on 13 October, the leaderless Yorkist army knelt in submission before King Henry and were graciously pardoned. It was later discovered that the Duke of York had also abandoned his wife, Cecily Neville, Duchess of York, his two youngest sons, George and Richard (later Richard III), and his daughter Anne. They were found standing at the Market Cross in Ludlow. Cecily and her children were placed in the care of her sister Anne, wife of Lancastrian supporter Humphrey Stafford, 1st Duke of Buckingham. Unfortunately the Lancastrian army then plundered Ludlow, committing many outrages and drunken acts.

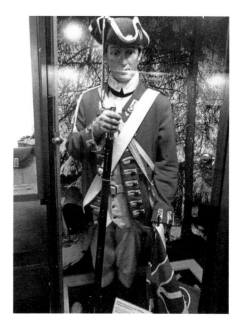

Replica uniform of a soldier of the 53rd during the American Revolutionary War 1755–83. (Courtesy of Shropshire Regimental Museum)

3. Foreign Conflicts

The 53rd Regiment of Foot

The American Revolutionary War began in 1775 when British troops were sent to Concord to confiscate militia ordnance. In June 1776, as part of troops under the command of Canadian Governor Sir Guy Carleton, the 53rd Regiment of Foot fought at the Battle of Trois-Rivieres, and were present to some extent at the Battle of Valcour Island in October.

Against the continuing American threat to the Canadian border the British government appointed Major-General John (Gentleman Johnnie) Burgoyne to lead the offensive against the American rebels. His army, including the 53rd Foot, part of General Simon Fraser's force, proceeded down Lake Champlain in the summer of 1777, reaching Fort Ticonderoga in July. Observing the British batteries sited on Sugar Hill, the Americans abandoned the fort.

Leaving some of the 53rd behind to defend the fort and its outlying defences, the regiment joined Burgoyne's advance on Albany. The grenadiers and light infantry units of the 53rd were subsequently involved in the Battle of Hubbardton, Vermont, on 7 July, and the Battle of Freeman's Farm 17–19 September, and again at the Battle of Bemis Heights, a densely wooded plateau about 10 miles south of Saratoga. On 7 October 1777, at Saratoga the British found themselves facing a continental army more than double its size, forcing

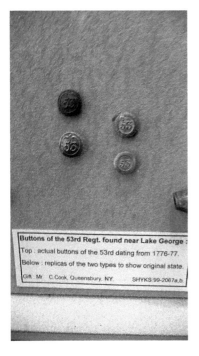

Buttons of the 53rd Regt. found near Lake George :
Top : actual buttons of the 53rd dating from 1776-77.
Below : replicas of the two types to show original state.
Gift : Mr. C.Cook, Queensbury, NY. SHYKS:99-2067a,b.

Buttons, 53rd Regiment of Foot, found near Lake George, New York State, USA. The top two are original and date from 1776–77, but the bottom two are replicas. (Courtesy of Shropshire Regimental Museum)

Burgoyne to surrender. The men left behind burned Fort Ticonderoga and its outlying defences on Mount Independence before returning to the Canadian frontier.

In 1778, soldiers from the 53rd's other eight companies joined Major Christopher Carleton's unit, which included Indians, carrying out raids. Then in 1780, the Burning of the Valleys campaign along Otter Creek in Vermont, also known as the Royalton Raid, was led by Lieutenant Richard Houghton of the 53rd. Three towns – Royalton, Sharon and Tunbridge in East Vermont – were burned by his force, which included grenadiers plus around 300 Mohawk warriors.

The Flanders Campaign, 1793–94

The French Revolution began on 4 July 1789 with the storming of the Bastille in Paris, and in 1793 the new French administration declared war on Great Britain. The 53rd Regiment of Foot was one of the first units to be sent to Flanders, sailing from Edinburgh in March to join the army of the untried allied commander, twenty-six-year-old Prince Frederick, Duke of York and Albany.

The Battle of Famars, May 1793

The 53rd saw action at the Battle of Famars in Northern France against an already dispirited and tired French Republican army, further weakened by detachments transferred to serve in the War of the Vendee.

The French camp at Famars sat atop a ridge bordered on the east by the River Rhonelle (all bridges and fords had been destroyed). The Duke of York's first column, consisting of sisxteen battalions and eighteen squadrons was to spearhead the main attack. The second column including the 53rd were part of Major-General Ralph Abercromby's brigade. Thick early morning fog delayed York's plan to cross the River Rhonelle south of Famars over trestle bridges near the village of Artres. When the fog cleared, across the River York observed French infantry supported by artillery facing them at their intended crossing point. The French opened fire immediately. Leaving behind a few Austrian field guns and troops to keep the French busy, the Duke of York turned his men around and counter-marched 2 miles to the south-east, fording the river unopposed. The outflanked French were driven back, but then held. With darkness approaching York postponed the final assault until next morning. However, when the new day dawned the French had already gone.

The Siege of Valenciennes 13 June–28 July 1793.

The French garrison, swelled by troops from Famars, was blockaded by part of the Duke of York's allied army. York's columns, including the Brigade of Guards, were supported by part of Abercromby's Brigade including the 53rd Regiment of Foot. On 26 July 1793, York's army stormed the main hornworks (an element of the Italian Bastion system of fortification, its face flanked with a pair of demi-bastions) on the eastern side of the town, and two days later the Valenciennes garrison surrendered; its defenders were allowed to march away with their honours, minus their weapons and munitions.

The Siege of Dunkirk, August 1793

On 22 August 1793 the Duke of York's army of 20,000 British, Hanoverian, Austrian, and Hesse-Lassel troops laid siege to one side of the fortified French border port of Dunkirk. Major-General Ralph Abercromby and Lieutenant-General Sir William Erskin

commanded the British forces, which included the 53rd Foot. Despite Dunkirk's defences being in a dilapidated condition the attack did not go to plan when a Royal Navy fleet bringing guns and gunners failed to materialise. The French Committee of Public Safety dispatched 40,000 troops to support the original 5,000 defenders, now bolstered by over 2,500 combatants, many from Valenciennes. The French poured round after round of grapeshot and round shot into the besiegers, killing or wounding seventy-four British, 170 Austrians, and fifty-five Hessian soldiers. With no heavy siege artillery and naval support, French gunboats were able to bombard York's seaward flank. Transport ships arrived the next day, but without guns, only gun crews, and also the promised support from Dutch troops not materialise. When the French opened the town's sluices the surrounding fields and British camp and trenches were turned into a mud bath, and soon an epidemic of Dunkirk Fever broke out. York's position was untenable, and two days later the siege was abandoned. The allies withdrew to Veurne (Furnes) and from there to Diksdmuide. York left Abercromby in Veurne with 3,000 men where they remained until 14 September. Ironically the navy arrived at Nieuwpoort three weeks too late.

The Siege of Nieuwpoort, October 1793

Nieuwpoort was defended by under 1,300 men, mainly of the 53rd Foot, plus two batteries of Hessian guns and a few dragoons. A strong French force totalling more than 12,000 marched from Dunkirk, capturing Veurne en route, and on 24 October opened up a fierce bombardment. Three days later Nieuwpoort was reinforced by a battalion of Hessians. The French abandoned the siege when they learned that the Duke of York's forces were marching to the port.

For its heroic defence the 53rd was awarded its first battle honour.

The Battle of Tournai, May 1794

The battle began between 6 and 7 a.m., and it was soon realised that key to the battle was the capture of the village of Pont-a-Clien on the River Scheldt downstream from Tournai. General Fox's brigade, including the 53rd, captured the village despite Fox having fewer than 600 men.

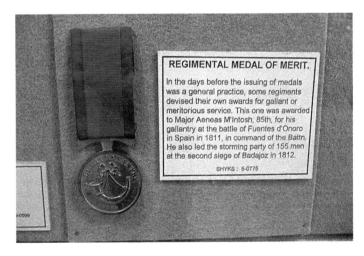

Regimental medal of merit awarded to Major Aeneas M'Intosh, 85th, for his gallantry at the Battle of Fuentes d'Onoro and the storming of Badajoz. (Courtesy of Shropshire Regimental Museum)

For their heroic bravely in this action the 53rd received their second battle honour. After a brief spell in England to recruit and rest, the 1st Battalion of the 53rd sailed for India in 1805, seeing active service at South Mahratta (1809), Kalunga in Nepal (1812), and in the Pindarree War (1817–19).

The Peninsular War, 1807–14

The 1st/53rd were in India and not involved in the Iberian Peninsular Campaign, however, the 2nd Battalion, raised in 1803 in Sunderland, played an active part, fighting in a number of important battles. In 1809 the battalion's strength was thirty-one officers, thirty-four sergeants, seventeen drummers and 688 rank and file.

On 4 April 1809 transport ships carrying 2/53rd anchored in the River Tagus abreast of the magnificent Castle of Beleme, Lisbon, disembarking to the small town of Almada on the southern bank of the river. From there the battalion travelled by boat up the Tagus to Villa Franca, marching from there to Porto (Oporto).

The Battle of the Douro, 12 May 1809

Following General Sir John Moore's retreat to Corunna in northern Spain, and the subsequent defeat and evacuation in January 1809, the British army's Peninsular campaign appeared to be dead and buried until the reinstatement as commander of Sir Arthur

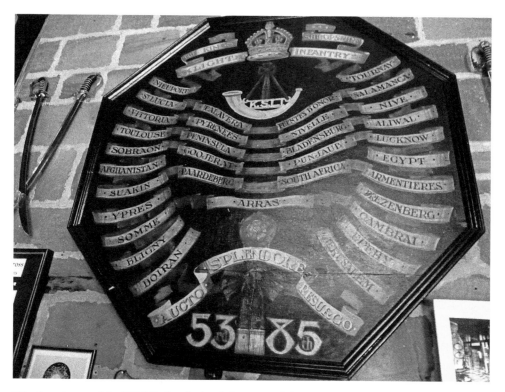

Wooden plaque of the KSLI, listing the battle honours of the KSLI, the 53rd and the 85th Regiments of Foot. (Courtesy of Shropshire Regimental Museum)

Wellesley, who landed in Lisbon on 22 April 1809. In May Wellesley marched a combined British and Portuguese army north to attack Marshal Soult's French army positioned on the north bank of the River Douro; Soult had ordered all boats destroyed or moved to the north bank of the river. The 2nd/53rd Regiment of Foot were part of Brigadier-General the Hon Alexander Campbell's 2nd Brigade, part of Major-General Sir Charles Colville's 4th Division.

On the morning of 12 May 1809, a British officer learned that a number of unguarded wine barges had been spied on the opposite bank half sunk in mud. Local residents produced a boat they'd hidden in reeds, which they now rowed across to the northern bank, bringing the barges back. One company of the 1st/3rd Buffs crossed the river in four journeys, occupying a derelict seminary. When the French realised what was happening they launched ferocious attacks, until driven back with heavy casualties by several British batteries of field guns. All Marshal Soult's subsequent attacks were resisted successfully. Around noon Soult sent reserve troops who were guarding the Porto waterfront to bolster the attack enabling the citizens of Porto to get other boats to the southern bank. Four British battalions including the 2nd/53rd Foot crossed to the city from Villa Nova. Soult realised his position was untenable and ordered the retreat.

The Battle of Talavera, 28 July 1809

The 2nd/53rd were part of Campbell's 1st Brigade, 4th Division, temporarily commanded by Campbell himself.

On 2 July 1809, Wellesley's troops crossed the Spanish border planning to link up with General Cuesta's and General Venegas' Spanish armies before launching an assault on French occupied Madrid. However, faced with an overwhelming French force of around 46,000 men under Marshal Victor blocking their path, the Spanish armies retreated back to Talavera, rejoining Wellesley's forces. Meanwhile Marshal Soult with 30,000 troops marched south intending to cut the British army from their Portuguese base.

The area behind the Spanish lines was a ridge of high ground with the Cerro de Medelin at its base. Below that lay a narrow valley, and beyond that the peaks of the Sierra de Segurilla mountains. Sir Arthur Wellesley favoured the use of high ground and so deployed his troops on the Cerro de Medelin. On the evening of 27 July, Marshal Victor's corps advanced up the slope reaching the summit before the British realised, causing much confusion until General Rowland Hill led a reserve brigade up the hill and drove the French back. A second French offensive was supported by a battery of fifty field guns. Wellesley ordered his troops to lie down behind the crest of the hill out of the line of artillery fire, then as the French breasted the summit the 29th and 48th Regiments of Foot rose up in a bayonet charge that sent the French back down the hill. The next French attack, at the lowest point of the hills, was driven back by the 53rd Foot and the 7th Fusiliers after bitter fighting in which Campbell was severely wounded. A third French assault met with no success, as did a flanking manoeuvre. Seeing the hopelessness of their position, the French retreated during the night leaving behind several pieces of ordnance.

Soult's attempt at cutting the British route back to Portugal was foiled when Craufurd's Light Brigade secured the bridge at Almaraz, allowing Wellesley's allied army to march back towards the Portuguese capital.

The Battle of Bussaco, 29 September 1810

The 2nd/53rd were part of the 1st Brigade, 4th Division, commanded by Major-General Lowry Cole.

Marshal Andre Massena had taken command of the French forces in May 1810 with orders from Napoleon to capture Lisbon and drive the British army out of the Iberian Peninsular.

Wellesley's engineers were busy constructing a string of fortifications across the Lisbon isthmus, known as the Lines of Torres Vedras, so it was vital to delay the French advance until the lines were completed. Massena's advance into Portugal had so far failed to bring the British and Portuguese forces to battle; instead Wellesley's troops fell back towards Lisbon, allowing Massena's forces to capture the Spanish city of Ciudad Rodrigo and the Portuguese fortress of Almeida.

Finally Wellesley paused his army at Bussaco, north of Coimbra, positioning his forces along a long high ridge. The French attacked early in the morning but each assault was repulsed. Seeing the failure of all their attacks, Massena called off the assault, and Wellesley's army withdrew south towards Lisbon. During the battle, the 53rd Foot had been in position on the north of the line but were not attacked.

During the winter of 1810, Marshal Massena's French army slowly starved in front of the Lines of Torres Vedras until hunger forced them to retreat back to Spain, leaving behind a garrison of 1,400 at Almeida under General Brenier. Wellesley, now Lieutenant-General Viscount Wellington, followed, besieging Almeida in an attempt to draw Massena from Ciudad Rodrigo to raise the siege.

The Battle of Fuentes de Oñoro, 3–5 May 1811

The 2nd/53rd were part of the 1st Brigade, now commanded by Colonel Hulse, part of Major-General Alexander Campbell's 6th Division. During the battle, the 53rd Foot were positioned on the northern slopes but were not attacked.

Replica Baker rifle. (Courtesy of Shropshire Regimental Museum)

Campbell's 6th Division, including the 53rd, was part of the allied Siege of Almeida, attempting to starve out the French defenders, but General Brenier and his men somehow managed to slip away on the night of 10/11 May.

The Battle of Salamanca, 22 July 1812

The 2nd/53rd were now part of Major-General Hulse's 1st Brigade, 6th Division, under Major-General Clinton.

After capturing Badajoz and Ciudad Rodrigo, Wellesley's (now Lieutenant-General the Earl of Wellington) allied army pushed further into Spain until a French attack by Marshal Marmont's forces forced the allies back to Portugal. Wellesley's ruse of concealing the majority of his army convinced the French that all they faced was a small rearguard. The trap was sprung. The 3rd Division concentrated on hitting the head of the French column, the 4th and 5th Divisions attacked the centre supported by the 6th and 7th Divisions and two Portuguese brigades of infantry. Finally, after fierce fighting, the French turned and fell back, pursued by British cavalry. The cavalry charge was halted when a brigade of French infantry formed squares, enabling the French to launch a counter-attack. This in turn was stopped by men of the Portuguese Brigade of the 5th Division. Clinton's 6th Division, including the 53rd Foot, then succeeded in driving the French back, forcing them to retreat.

Success at Salamanca was tarnished by the disastrous Siege of Burgos in which the 53rd suffered greatly.

The Battle of Vitoria, 21 June 1813

The 2nd/53rd were now part of the 2nd Provisional Battalion with the 2nd Foot, 1st Brigade, commanded by Major-General William Anson, 4th Division under Major-General Lowry Cole.

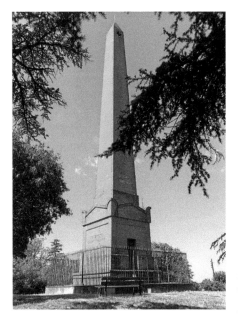

French memorial column to those who died at the Battle of Toulouse, 4 April 1814, on the Hill of Jolimont. (Courtesy of Naomi Holdstock)

Wellesley, now Marquis of Wellington, advanced his forces into north-east Spain, forcing the armies of France to retreat to Vitoria where they congregated the remnants of their armies of the south, centre and Portugal waiting to be reinforced by the army of the north. The initial allied attack failed to cross the River Zadorra, although further to their left flank the Spanish Division managed to cross the river and block the road to France. The 3rd Division eventually crossed east of Tres Puentes and the 4th Division, including 2/53rd, crossed at Nanclares. Faced with such a large allied force the French retreated in chaos, abandoning their baggage trains, which were looted by the allied soldiers.

The Battle of the Pyrenees, 25–27 July 1813

The Battle of the Pyrenees was actually a number of battles in which as part of Anson's 1st Brigade, in Lowry Cole's 4th Division, the 2/53rd were involved to one extent or another. Including the Battle of Roncesvalles, 25 July 1813, Sorauren, 28–30 July 1813, and Nivelle on 10 November 1813, as well as being present at the Siege of San Sebastian in August 1813.

Following the defeat at Vitoria, Marshal Soult brought together what was left of four French armies into a single force of 80,000 troops, directing simultaneous attacks on the Pyrenean passes at Maya and Roncesvalles, and attempting to relieve the Siege of Pamplona. The French succeeded in taking the Maya Pass from the 2nd Division, but were stopped by the 7th Division. The 4th Division, including 2/53rd, initially held

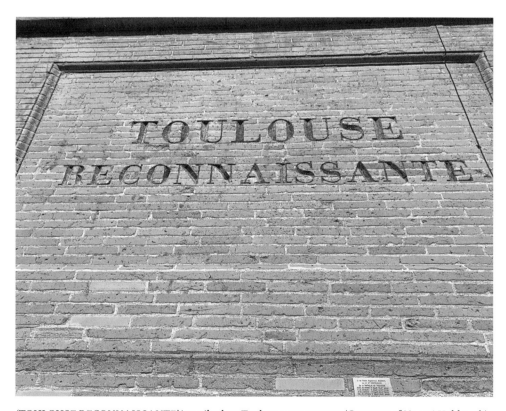

'TOULOUSE RECONNAISSANTE' inscribed on Toulouse monument. (Courtesy of Naomi Holdstock)

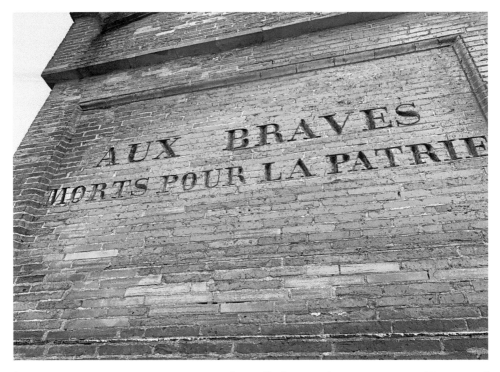

'AUX BRAVES MORTS POUR LA PATRIE' inscribed on Toulouse monument. (Courtesy of Naomi Holdstock)

Roncesvalles Pass, but General Cole, in fear of another French attack, ordered a retreat towards Pamplona. When Sir Thomas Picton arrived with his 3rd Division, Cole convinced him to also retreat. The French advance got to within 10 miles of Pamplona, before being stopped by the 3rd Division. On 27 July Wellesley reinforced the 3rd Division and the defeated French retreated over the border into France.

The Battle of Toulouse, 4 April 1814

The 2nd/53rd were again part of Anson's 1st Brigade, 4th Division under Lowry Cole. Toulouse was the last major battle of the Peninsular War, a city defended by Marshal Soult's army.

The British 2nd Division together with the Portuguese Division feinted to attack the fortified suburb of St-Cyprien, while the 3rd Division attacked the Pont Jumeaux where they were pushed back with heavy casualties. The 4th and 6th Divisions, including the 53rd, advanced through muddy fields down the west bank of the River Hers (Ers), and a little behind schedule attacked the Heights of Calvinet. A French counter-attack was driven back uphill as the British advanced up the slope, fighting their way to the top of the heights despite bitter resistance. Swinging north along the heights the two British divisions pushed back the French defenders. The heights lost, Soult pulled back his soldiers behind the city's fortifications and that evening withdrew out of Toulouse. On the following morning, a delegation of city officials handed the city over to Wellesley. That afternoon, news came of Napoleon's abdication.

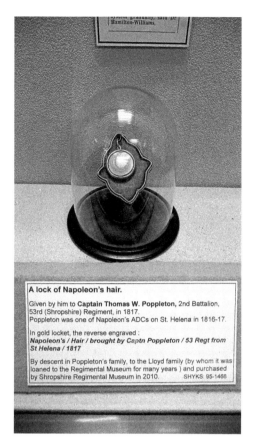

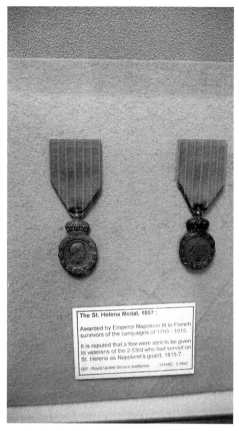

Lock of Napoleon Bonaparte's hair. (Courtesy of Shropshire Regimental Museum)

St Helena medal, 1857 (both sides). (Courtesy of Shropshire Regimental Museum)

After the war the 2nd Battalion of the 53rd remained in France on garrison duty, but took no part in the Battle of Waterloo in 1815.

Following the Emperor's capture, 2/53rd Regiment of Foot was appointed to be Napoleon Bonaparte's guard for his exile on the Atlantic island of St Helena.

The 2/53rd returned home in 1817, and was disbanded as part of the government's decision to reduce the size of the British Army, resulting in the 53rd becoming a single battalion regiment again. Men from the redundant 2nd Battalion volunteered to serve in the 1st Battalion.

The 53rd sailed from Liverpool to India in August 1844; however, before departing, 241 men were declared unfit for overseas service.

The First Sikh War (Sutlej Campaign), 1845–46

Arriving at Cawnpore in March 1845, detachments of the 53rd were ordered to Delhi to join the army of the Sutlej. After a forced march the 53rd linked up with General Sir Harry Smith's column marching to relieve Ludhiana, which was being threatened by a large Sikh army. On 21 January 1846, at around 10 a.m., as the column passed the

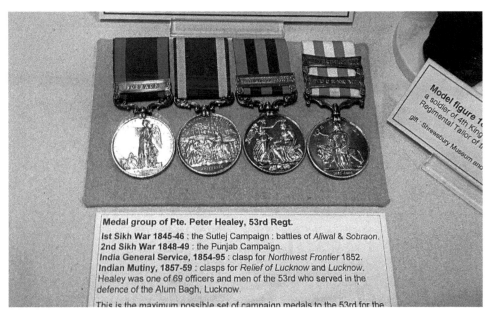

Four-medal group of Private Peter Healey, 53rd Regiment of Foot, from the 1st and 2nd Sikh Wars, India General Service and India Mutiny. (Courtesy of Shropshire Regimental Museum)

village of Baddiwal Sikh forces opened up with a heavy barrage on the column's flank. When Sikh cavalry were observed the 53rd immediately formed square. Unfortunately nine men were killed by one round shot, but no cavalry charge came. The 53rd now acted as rearguard, covering the column as it continued to Ludhiana, losing a large amount of baggage in the process. During the retreat several of the 53rd were killed or wounded by Sikh skirmishers.

Battle of Aliwal, 28 January 1846

The 53rd was part of Major (later Brigadier, Sir) Archdale Wilson's 3rd Brigade, Infantry Division, positioned on the left edge of the British advance. After marching about 10 miles, the enemy were observed on a slope around 1-mile distant. Behind a cavalry screen the infantry formed line, the cavalry then riding to the flanks, allowing the infantry to move forward. The Sikhs opened up with artillery, but the British continued their advance to within musket range, then charged. On the flanks the 16th Lancers and 3rd Light Cavalry scattered the enemy. The 53rd was detailed to clear Bundree, a nearby village around 300 yards from the crest of the slope the 53rd had fought its way up. Then the Sikhs retreated across the river in disarray, abandoning weapons and equipment. The 53rd lost six men killed and eight wounded. Sir Harry Smith mentioned the 53rd in his dispatch, writing that they were 'a young regiment, but veterans in daring gallantry and regularity,' adding further praise for Lieutenant-Colonel Phillips for his bravery and coolness.

On 3 February 1846 the 53rd and the rest of the column joined the main army of the Sutlej under Sir Hugh Gough. The Sikhs were now in a strong defensive position on the left bank of the River Sutlej near the village of Sobraon.

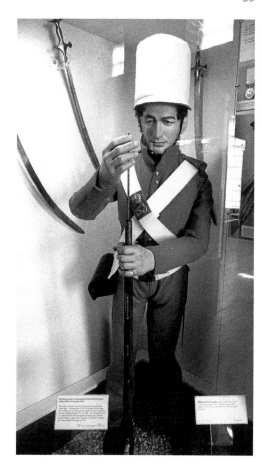

Replica uniform of a sergeant, 53rd Regiment
of Foot, at the Battle of Sobraon 1846.
(Courtesy of Shropshire Regimental Museum)

Battle of Sobraon, 10 February 1846

Brigadier Stacey's 7th Brigade, including the 53rd, took up prearranged positions of the
extreme left of the British line while British gunners softened up the Sikh positions. The
53rd waited under cover in the bed of a dry stream for two hours, then came the order to
advance in double time. Under heavy fire they halted around 200 yards from the enemy,
and when the Sikh's threatened the British left, they were scattered by musket fire and
grapeshot. The 53rd then surged forward, clearing the Sikh trenches, forcing the defeated
Sikhs to retreat into the River Sutlej where the British poured round after round into
them for almost an hour. In the action, the 53rd, who were the first regiment to close with
the enemy, suffered many casualties. Senior Captain Warren was killed and Lieutenant
Lucas severely wounded – later dying. Six other ranks were also killed and eight officers
wounded, of these Captain Smart, Lieutenant Clarke, and Adjutant Dunning and twelve
men died later of their wounds. The regimental colours also suffered, the two pike staffs
broken and the men nearby shot down.

On 20 February 1846 the army camped outside Lahore when news came that a treaty
had been agreed. The Sikh campaign now ended, the 53rd marched to Ambala (Umballa)
on the Punjab border, arriving on 8 April 1846. The uneasy peace lasted until 1848.

The Second Sikh War (Punjab Campaign), 1848–49

When hostilities commenced the 53rd Foot was garrisoning Lahore, sharing duty with Sikh troops. In September 1848 as relationships worsened the Sikh force in Lahore was disbanded.

The Battle of Gujerat (Googerat), 21 February 1849

The final battle of the Second Sikh War. The 53rd formed part of a brigade detailed to escort heavy artillery, arriving at the Punjabi city of Rawalpindi on 27 March, but by then the Sikh army had already been defeated and pursuit of them had ceased, thus ending the campaign.

At the conclusion of the war, the Kingdom of Punjab was annexed to British India and as part of the Last Treaty of Lahore the famous Koh-I-Noor (Persian for Mountain of Light), a large colourless diamond, was ceded to Queen Victoria. The 53rd was given the prestigious task of guarding the famous stone. The 53rd remained on the north-west frontier until 1852, often engaging in operations against local tribes.

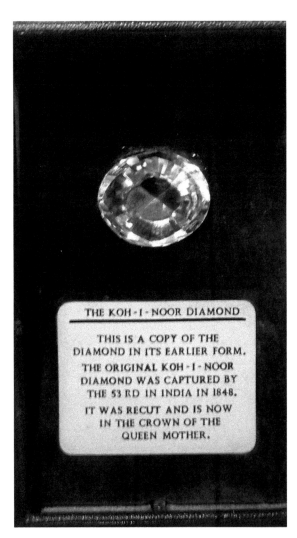

Copy of the famous Koh-I-Noor diamond. (Courtesy of Shropshire Regimental Museum)

The Indian Mutiny, 1857

The 53rd, based at Calcutta, was detailed to disarm Indian regiments in the city, over the next two years, playing a leading role in the suppression of the mutiny, being involved in the Relief of Lucknow (1857), the Battle of Cawnpore (1857), and the recapture of Lucknow (1858). During the fighting, soldiers of the regiment earned five Victoria Crosses. Further active service followed in Rohilkand and Oudh before the regiment sailed home in 1860.

Battle Honours of the 53rd Regiment of Foot

Nieuport 1793 Flanders Campaign
Tournay 1794 Flanders Campaign
St. Lucia 1796 West Indies
Talavera 1809 (2nd Battalion) Peninsular War
Salamanca 1812 (2nd Battalion) Peninsular War
Vittoria 1813 (2nd Battalion) Peninsular War
Pyrenees 1813 (2nd Battalion) Peninsular War
Nivelle 1813 (2nd Battalion) Peninsular War
Toulouse 1814 (2nd Battalion) Peninsular War
Peninsula 1809–14 (2nd Battalion) Peninsular War
Aliwal 1846 1st Sikh War (Subject Campaign)
Sobraon 1846 1st Sikh War (Subject Campaign)
Googerat 1849 2nd Sikh War (Punjab Campaign)
Punjab 1848–49
Lucknow 1857–58 Indian Mutiny

In 1881, as part of the Childers Reforms, the 53rd (the Shropshire) Regiment of Foot and the 85th (King's) Light Infantry amalgamated to form the King's Light Infantry (Shropshire Regiment) based at newly built Copthorne Barracks and depot in Shrewsbury, later restyled the King's Shropshire Light Infantry.

The 85th Regiment of Foot

Raised in Shrewsbury in 1759, the 85th first saw service in 1760 when the regiment was sent to Belleisle, a small rocky island off the coast of Brittany. Prime Minister Pitt proposed this expedition wanting to humiliate the French Revolutionary government.

During the Seven Years' War the regiment sailed for Portugal in 1762 as part of a British force commanded by Brigadier-General Burgoyne, sent to counter a Spanish invasion, seeing service at Valencia d'Alcantara, and at Villa Velha. The Peace of Paris saw the end of hostilities, and with this the regiment was disbanded.

In 1779 the regiment was raised as the Westminster Volontiers, with Charles, 3rd Earl of Harrington, as its colonel. In America the rebel army were triumphing in their fight for independence and Spain took advantage of this by declaring war on Great Britain. However, the newly formed regiment wasn't sent to America; instead it was shipped out to Kingston, Jamaica, arriving 1 August 1780, where it suffered a devastating epidemic of yellow fever.

146 Eighty-fifth Reg. of Foot, or Royal Volunteers. Eighty-fifth Reg. of Foot, or Royal Volunteers. 147

Rank.	Name.	Regiment.	Army.
Colonel	John Craufurd	21 July 1759	
Lieut. Colonel	Wm. Visc. Pulteney	21 July 1759	
Major	Hugh Williams, Bt.	30 July 1759	10 Jan. 1756

Captain
Nathaniel Heywood — 30 July 1759
William Skinner — 2 Aug.
Charles Cooper — 3 do.
James Langham — 4 do.
Charles Lord Brome — 5 do.
Hugh Lord Warkworth — 6 do.
Peter Bathurst — 7 do.
Edmund Nugent — 9 do.
Lockhart Gordon — 10 do.
St. John Jeffreys — 11 do.
Temple West — 12 do.
Charles Egerton — 13 do.
William Forrester — 14 do.
—— Matthews — 15 do.

First Lieutenant
James Lloyd — 2 Aug. 1759
George Maxwell — 3 do.
William Cawthorn — 4 do.
James Dawson — 5 do.
George St. Clair — 6 do.
Joseph Adams — 8 do.
Andrew Bruce — 9 do.
Hatton Dawson — 10 do.
Pryse Donaldson — 11 do.
Woodford Rice — 12 do.
Thomas Pemberton — 13 do.
George Sandys — 14 do.
James Rooke — 15 do.
Henry Hatton — 16 do.

First Lieutenant
James Stewart — 17 Aug. 1759
Richard Shipley — 18 do.
Robert Barry — 19 do.
Holland Williams — 20 do.
—— Nugent — 21 do.
—— Cooper — 22 do.
Henry Williams — 25 do.
Geo. Salusbury Townshend — 26 do.
Charles Jones — 27 do.
Miles Allen — 28 do.
—— Afton — 29 do.
—— Glynne — 31 do.
Roger Price — 20 Dec.
James Johnes — 1 May 1760
Nathaniel Merfon — 23 Oct.
Richard Boycott — 24 do.

2d Lieutenant
Charles Ware — 6 Aug. 1759
Owen Meyrick — 7 do.
—— Lambert — 8 do.
Frederick Thackeray — 9 do.
—— Humphreys — 10 do.
Richard Lucas — 11 do.
Patrick Bridon — 14 Oct.
Robert Wylde — 15 do.
Martin Adamfon — 20 Dec.
Patrick Yeoman — 1 May 1760
Richard Gough — 23 Oct.
Charles Williams — 24 do.

Chaplain — Robert Thorpe — 29 Sept. 1759
Adjutant — Richard Gough — 2 Aug. 1759
 George Maxwell — 4 Aug. 1759
Quarter-Mafter — John Roberts — 4 Aug. 1759
Surgeon — —— Douglas — 10 May 1760

Agent, Mr. Calcraft, Channel-Row, Weftminfter.

Army list, 1759–60, of officers of the 85th Regiment of Foot or Royal Volunteers. (Courtesy of Shropshire Regimental Museum)

On 25 July 1782 what was left of the regiment sailed from Bluefields, Jamaica, for England. It would appear that the men were spread over at least three ships, a number (possibly around 300 men) in the troop ship *Ville de Paris*, a three decker captured earlier by Admiral Rodney at the Battle of the Saintes.

Along with other vessels in the fleet the ship foundered on 19 September 1782 in the Central Atlantic Hurricane off Newfoundland with the loss of all but one on board – James Wilson. Altogether 3,500 men lost their lives in the tragedy. The remaining men of the 85th mustered at Dover Castle, and following this the regiment was once again disbanded.

Ten years of relative peace followed, but in 1793, when France declared war on England, the regiment was reborn with Lieutenant-Colonel George Nugent as its colonel, receiving its designation in 1794 as the 85th (Bucks Volunteers) Regiment of Foot. In August of that year the new regiment was sent to Walcheren as part of a force of British, Dutch, Hanoverians and Austrians commanded by the Duke of York. In a disastrous campaign York's army was pushed back to the River Ems in north Germany, from where they returned home.

Next stop for the 85th was garrison duty in Gibraltar from 1795, returning to England in 1797, for a time stationed at Bridgnorth. Renewed hostilities in Holland saw the regiment despatched there in July 1799 under the command of General Ralph Abercromby. However, after the Convention of Alkmaar was signed the regiment returned to England.

Above: Officer's shako, 1869–78, 85th King's Light Infantry Regiment. (Courtesy of Shropshire Regimental Museum)

Right: Officer's full dress helmet, 1878–81, 85th King's Light Infantry Regiment. (Courtesy of Shropshire Regimental Museum)

In 1800 the order was given to raise a second battalion. This completed, both battalions were ordered to Bagshot Heath to join the Camp of Instruction.

In 1801 the 1st Battalion was stationed on Madeira, moving in 1802 to Jamaica for six years. While there, following the Peace of Amiens, the 2nd Battalion was disbanded, its effective NCOs and men transferring to the 1st Battalion.

The regiment returned to England in 1808 where it was ordered to Shorncliffe Camp, learning it had become a light infantry corps, receiving instruction on the operation of light infantry at Brabourne Lees in 1809.

The Walcheren Expedition, 1809

With Napoleon Bonaparte continuing to flex his military muscles in the Low Countries, the 85th (Light Troops), commanded by Lieutenant-Colonel Cuyler, were shipped to Holland as part of a huge expeditionary force. Landing on 30 July 1809 to besiege the strategic port of Flushing (Vlissingen) on swampy Walcheren Island, the most important island in the Schelde Estuary. Following the French flooding the land, by 20 August 1809 men began to get sick with malaria, typhus and typhoid fever, collectively known as Walcheren Fever. Troops were evacuated from Flushing and by October only 4,500 of the original 40,000 troops were fit for duty. Final evacuation in this debacle was completed on 23 December 1809. Of its original compliment of 570 men the 85th were reduced to an active compliment of ninety-nine.

Back home again active recruitment brought the compliment to 936 men, who were now sent to Portugal to join Sir Arthur Wellesley's army.

The Battle of Fuentes de Oñoro, 3–5 May 1811

The 85th were part of Brigadier-General John Sontag's 1st Brigade, 7th Division, commanded by Major-General Houston. Wellesley again positioned his army on a ridge and in the streets of the village of Fuentes de Oñoro.

French Army badges c. 1812. (Courtesy of Shropshire Regimental Museum)

Under Marshal Massena the French attacked on 3 May, but by nightfall were pushed back. On 5 May, when a large force of French cavalry and two divisions of infantry attacked, the 7th Division were in danger of being overrun. The 85th and the 51st, together with Portuguese caçadores and Brunswick Oels, were caught in open ground and surrounded by French cavalry. They were saved when Brigadier-General Robert Crauford's Light Division was sent in, enabling the two divisions to retreat. When French cavalry threatened the British and Portuguese troops formed square, demonstrating how to beat French cavalry using a combination of well-disciplined formations coupled with speedy movement and accurate rifle fire. Once the Light Division and 7th Division reached high ground, Wellesley's flank was secure and Massena began to withdraw. The 85th suffered eighty-five casualties in this battle.

For their brave efforts during this battle the 85th Regiment of Foot were awarded the Battle Honour Fuentes d'Oñoro.

The Siege of Badajoz, 6 April 1812

The 7th Division and the 85th stormed the outwork Fort of St Christoval (Christobal), opposite the city on the north bank of the River Guadiana.

At Badajoz, General de Division Armand Philippon, French Governor of Badajoz, was captured and paroled, taking up residence in Oswestry, Shropshire. However, in July 1812 he broke his parole and was smuggled back to France.

After suffering severe casualties the regiment returned to Portugal and from there back to England with the objective of bringing it back to full strength.

The Siege of San Sebastian, July 1813

The 85th, now commanded by Lieutenant-Colonel Thornton, returned to the Iberian Peninsular, landing on the north coast of Spain to take part in the Siege of San Sebastian, in the process capturing a strategic redoubt sited on one of the islands in the harbour.

The Battle of the Nivelle, November 1813

The 85th crossed into France at Bidassoa, seeing action in November, where it captured and held the village of Urogne. Following this the regiment led the pursuit of the French through St Jean de Luz. On 10 December 1813 Marshal Soult launched a surprise attack near the village of Bidart, but a great volley, followed by a bayonet charge, sent the French packing.

The 85th Regiment of Foot were awarded their second battle honour of the campaign: Nive.

The Siege of Bayonne, 11 April 1813

When the Peninsular Campaign was renewed in February after a harsh winter, the 85th were ordered to support the Siege of Bayonne. Then came the news that Emperor Napoleon Bonaparte had abdicated, and the war was at an end.

For their brave efforts during the Peninsular Campaign the 85th Regiment of Foot were awarded the Battle Honour Peninsular.

The Battle of Bladensburg, 24 August 1814

In May 1814 the 85th, commanded by Colonel William Thornton, marched to Bordeaux as part of the 1st Brigade of Major-General Robert Ross' small force of 4,500 troops to take part in the war against America, later known as the War of 1812. The objective of the enterprise was to draw American troops from the Canadian theatre. Sailing via Bermuda, Ross' army landed unopposed at Benedict on the River Patuxent, Chesapeake Bay, Maryland, America, on 19 August. Marching north along the river in intense heat, Ross' troops spent the first night at Nottingham, reaching Upper Marlboro the next day where Ross decided to camp for a second night. From there he was well suited to attack either the new US capital of Washington or Baltimore. He chose the former, marching his troops west and then north to advance on Washington from the north-east via a bridge over the River Anacostia (a tributary of the River Potomac).

Arriving around noon at the village of Bladensburg, 5 miles from Washington, Ross' army was faced by an American force occupying a strong defensive position on the brow of Lowndes Hill on the western bank of the River Anacostia with a bank of cannon covering the bridge. US President James Madison had arrived to observe the scene. In the first attack, the 85th doubled down Main Street under heavy fire, then assaulted the bridge. When the leading company attempted to cross men were torn apart by grapeshot from two cannons facing along the bridge, sweeping down all but a few. Those behind pushed on over the dead and dying and this second wave succeeded in clearing the bridge. The 85th suffered many casualties, among them Colonel Thornton, who was badly wounded. When the 2nd Brigade attacked their left flank the Americans scattered and ran for their lives, the rout becoming known as 'the

The colour of the First Harford Light Dragoons, captured at the Battle of Bladensburg, near Washington, America. (Courtesy of Shropshire Regimental Museum)

Bladenburg Races'. In this battle the British lost sixty-four men killed and 185 wounded, including fifteen killed and sixty-four wounded from the 85th. Ten Americans guns out of twenty were captured.

This victory opened the way for Ross' 3rd Brigade to march on to Washington. The 1st Brigade and the 85th marched in later. The British burned the Senate House, the President's House (now the White House), the library, the dockyard, arsenal, barracks, storehouses, a frigate, and many other small boats, returning to rejoin the fleet the following day to sail for Baltimore. Colonel Thornton and several others remained in Washington, their wounds too serious, and were taken as prisoners of war.

In 1826 the Battle Honour Bladensburg was confirmed.

The Battle of Baltimore (Battle of North Point), 12 September 1814

General Ross and his troops, including the 85th, commanded in Thornton's absence by Brevet Major Gubbins, landed at North Point on the Chesapeake, near Baltimore, in what was an abortive attempt to capture the city, a vital American port. After 5 miles of skirmishing General Ross rode forward to investigate firing and was mortally wounded by a stray shot. Facing 20,000 US troops and 100 guns, and without naval support due to the shallowness of the channel, the attack was abandoned.

Meanwhile in the bombardment of Fort McHenry, which guarded the north-west approaches to Baltimore Harbour on the Patapsco River, the British fired over 1,500 rounds, giving birth to a moment of monumental importance to America. Next morning in the subsiding rain the fort's defenders ran up the 42-foot-by-32-foot standard garrison flag of fifteen stars and fifteen stripes, which was clearly observed by all aboard ships in the river, including a prominent US attorney Francis Scott Key. Key was onboard the British ship *Minden*, where he had been attempting to negotiate the release of Dr William Beanes, who had been detained at Washington. The bombardment inspired Key to pen a poem, which was later set to the tune of an old drinking song, 'To Anacreon in Heaven' by John Stafford Smith in 1780, later known as 'The Star Spangled Banner', the anthem of the United States of America. A replica flag is still raised every morning. The first verse of the anthem sets the scene:

> O say can you see, by the dawn's early light,
> What so proudly we hailed at the twilight's last gleaming,
> Whose broad stripes and bright stars through the perilous fight,
> O'er the ramparts we watched, were so gallantly streaming?
> And the rockets' red glare, the bombs bursting in air,
> Gave proof through the night that our flag was still there;
> O say does that star-spangled banner yet wave
> O'er the land of the free and the home of the brave?

Released by the Americans, Colonel Thornton and the other prisoners of war rejoined the army on 9 October 1814, and on the 14th the British fleet sailed for Jamaica, arriving on the 31st.

The Battle of New Orleans, 8 January 1815

The 85th, commanded by Colonel Thornton, sailed from Port Royal, Jamaica, landing on Pine Island near New Orleans (30 miles from the sea) on 17 December 1814, forming the advance. Torrential rain by day and severe night frosts, plus the lack of trees – meaning no wood for fires – took its toll on morale. On 22 December Thornton's Brigade, consisting of the 85th plus five companies of the 95th Rifles, and Rocketeers, 100 sappers and 100 Royal Marines, were rowed under cover of darkness to a creek near New Orleans (marshy land made it impossible to reach on land). Next day Thornton's Brigade came under severe attack from American warships and infantry; the enemy was repulsed but the British retired. The 85th lost fifteen killed and sixty-nine wounded in the fight. The 85th now joined Major-General Gibbs' 2nd Brigade, part of the newly arrived Sir Edward Pakenham's command with orders to capture the city. In the first foray the 85th lost seven killed and fourteen wounded. The British now spent time constructing batteries and digging a canal along which to bring up the necessary boats, all the time under heavy American cannon fire. Colonel Thornton's force received orders to cross to the right bank of the Mississippi River and to capture the American redoubt gun batteries sited there, and to turn their own guns on the Americans. This they achieved, capturing seventeen guns despite insufficient boats being available to transport Thornton's entire force. Also due to a collapse of the canal's banks, only 350 men made the crossing. One man was killed and forty-four were wounded in this assault, including Colonel Thornton. Facing determined and overwhelming odds in a hostile landscape, Packenham took the decision to retreat. When the order to retreat came the 85th recrossed the river and joined the exodus back to the waiting fleet.

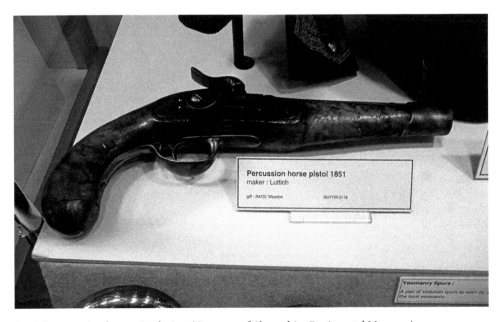

Luttich percussion horse pistol, 1851. (Courtesy of Shropshire Regimental Museum)

Unbeknown to the British and American forces around the Mississippi, the Treaty of Ghent had been signed on Christmas Eve around the time of the British landing, but of course the famous Battle of New Orleans went ahead despite the war being technically over. The successful American defence was led by General Andrew Jackson (later President Jackson). The remnants of the defeated British forces landed back in England on 9 May 1815.

In August the 85th received recognition for its gallant conduct and discipline in Europe and America since 1813 that henceforth it shall be known as the 85th (or Duke of York's Own) Regiment of Light Infantry, granted the motto *Aucto Splendore Resurgo* ('I rise again with increased splendour').

Early in 1821 the regiment earned a further unique distinction when officers of the 85th protected George IV from an unruly mob in Brighton at the Theatre Royal. The king rewarded the regiment a special dispensation from drinking his health or from having to stand for the national anthem, a custom that continued until the KSLI was amalgamated with other regiments. The regiment was also restyled the King's Light Infantry, becoming a royal regiment wearing uniforms faced with royal blue.

Following postings to Malta and Gibraltar in 1821–31, the Canadian frontier in 1836–38, the West Indies in 1843–46, Ireland during the famine, Mauritius in 1853–56, South Africa in 1856, Cape Colony and on the Natal frontier, all interspersed with time in Great Britain, the 85th were stationed at Lucknow, India, during the winter of 1878.

Replica officer's coatee, Shropshire Yeomanry Cavalry, 1823–28. (Courtesy of Shropshire Regimental Museum)

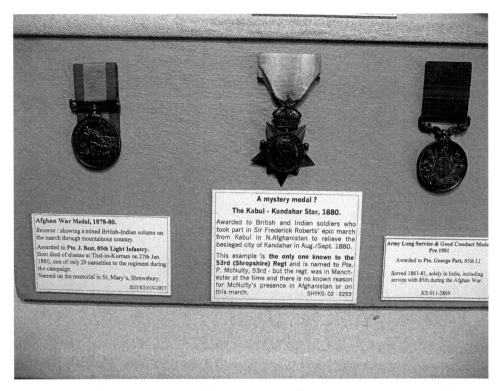

Afghan War medal, 1878–80; Kabul-Kadahar Star, 1880; and Army Long Service and Good Conduct medal, pre-1901. (Courtesy of Shropshire Regimental Museum)

In September 1879, a year after the Second Afghan War began, the 85th was sent to Afghanistan. It saw little action, mainly undertaking garrison and escort duty. Later that year the regiment was called into action, taking part in the destruction of Zawa, tribal capital of the Zaimusht.

Battle Honours of the 85th Regiment of Foot

Fuentes d'Oñoro 1811 Peninsular War

Nive 1813 Peninsular War

Bladensburg 1814 American War 1812–14

Afghanistan 1879-80 Second Afghan War 1878–80

In 1881 as part of the Childers Reforms, the 85th (King's) Light Infantry was amalgamated with the 53rd (the Shropshire) Regiment of Foot to form the King's Light Infantry (Shropshire Regiment) based at newly built Copthorne Barracks and depot in Shrewsbury, later restyled the King's Shropshire Light Infantry.

The King's Shropshire Light Infantry

Following the formation of the King's Shropshire Light Infantry (KSLI), the 53rd became the 1st Battalion KSLI, the 85th the 2nd Battalion KSLI. The 1st Battalion was sent to

Egypt as part of Sir Garnet Wolseley's British invasion force, garrisoning Alexandria and Cairo. A spell of duty on Malta followed, but in 1885 the 1st Battalion returned to Middle East to the port of Suakin on the Red Sea coast of Sudan, where local chieftain Osman Digna was proving troublesome. There is a memorial at Suakin to those killed.

For these campaigns the KSLI was awarded the Battle Honours: Egypt 1882; Suakin 1885.

In 1894 the 1st Battalion was stationed in Hong Kong, volunteering to bury the dead and disinfect dwellings during an outbreak of the plague that took the lives of over 3,000 Chinese residents. The KSLI, lost only one officer and one private to the disease. To mark this brave service each volunteer was presented with a special 'Plague Medal' – gold for the officers, silver for other ranks. After this 1/KSLI served in India, returning for duty in England and Ireland from 1903 until the outbreak of the First World War.

Hong Kong plague shield. (Courtesy of Shropshire Regimental Museum)

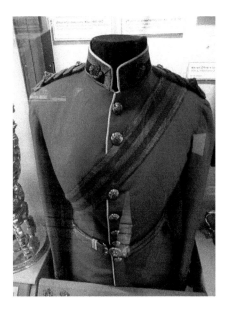

Officer's full dress tunic, 1882–1922. (Courtesy of Shropshire Regimental Museum)

The Anglo-Boer War

The 2nd Battalion was not called into action until the outbreak of the Second Anglo-Boer War in 1899, arriving in South Africa on 1 December 1899 as part of the 19th Infantry Brigade commanded by Major-General Horace Smith-Dorrien, part of the 9th Division, serving in the Kimberley area where the battalion played a pivotal role in the Battle of Paardeberg. The 2/KSLI advanced from the Modder River to Bloemfontein, capital of the Boer Republic, Orange Free State. Fighting began early on Sunday 18 February, the KSLI crossing the river to occupy a knoll called Gun Hill that commanded an area of scrub. Ground was taken over the next two days and on the 21st the KSLI advanced to within 550 yards of the Boer trenches. The next day's advance was met with fierce resistance and failure; the KSLI together with the rest of the attackers dug in. The final assault, led by the Royal Canadians and supported by other units including the 19th Brigade, brought about the Boer surrender on 27 February 1900. 2/KSLI suffered fifty casualties in the action.

2/KSLI were in action again on 7 March 1900 at Poplar Grove, fighting around Leuwkop Hill, forcing the Boers to retreat. In April the 9th Division was broken up, the 19th Brigade moving under the command of Sir Ian Hamilton, fighting in numerous actions including Israel's Poort, and taking the pass between the two peaks of Thoba Mountain while under intense fire, in addition to several battles and skirmishes around the small town of Belfast in Mpumalanga Province. The KSLI lost thirteen men killed and thirty-eight wounded in a train derailment. The 2nd/KSLI spent much of the rest of the campaign in the Eastern Transvaal on patrol, escort duty and on guard.

The Boers' hard-fought guerilla campaign finally ended on 31 May 1902 when the Boers agreed to the terms of the Treaty of Vereeniging.

Battle Honours: South Africa 1899–1902; Paardeberg.

Boer General Koos de la Rey.

The First World War

Next stop for 2/KSLI was India, stationed at Secunderbad at the outbreak of the First World War on 28 July 1914.

At the start of the war, in keeping with other infantry regiments, the KSLI was expanded. Eight of its battalions saw active service, earning sixty battle honours.

The 1st Battalion KSLI formed part of the 16th Brigade, 6th Division, in August 1914, landing at St Nazaire, France, on 10 September, arriving in time to fight in the latter stages of the Battle of Aisne and then Marne. They then moved to the infamous Western Front, seeing action in the First Battle of Ypres on 19 October – 22 November 1914, and in the Ypres Salient in 1915. In 1916 the battalion saw action in the Battle of the Somme: Flers-Courcelette, 15–22 September 1916; Morval, 25–28 September 1916 and Le Transloy, 1–18 October 1916. In 1917, 1/KSLI took part in the Battles of Arras and Cambrai, in 1918 served on the Hindenburg Line, and in the final operations against the Germans, later becoming part of the Rhineland occupation force. In all fifty-three officers and 986 other ranks were killed.

1/KSLI earned nineteen Battle Honours: France and Flanders, 1914; France and Flanders, 1915; France and Flanders, 1916; France and Flanders, 1917; France and Flanders, 1918; Aisne, 1914; Armentiers, 1914; Hooge, 1915; Somme, 1916; Flers-Courcelette; Morval; Le Transloy; Hill 70; Cambrai, 1917; Somme, 1918; Hindenburg Line; Epéhy; Cambrai, 1918; and Selle.

The 2nd Battalion KSLI joined the 80th Brigade, 27th Division, in August 1914, landing at Le Havre, France, on 21 December 1914. Engaged in some of the fiercest fighting in the Ypres Salient at St. Eloi, St. Julien, and Frezenberg Ridge in 1915, next they moved to the Somme. In December 1915 the battalion was ordered to Salonika in Greece, fighting

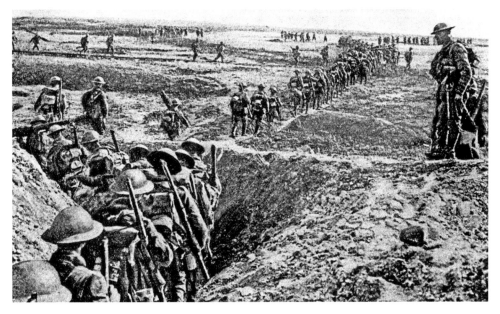

British troops on the front line, First World War.

the Bulgarians in Macedonia for almost three years, mainly on the Struma Front. In November 1918 the 2nd Battalion absorbed the 8th Battalion.

Seven Battle Honours were earned: France and Flanders, 1915; Macedonia, 1915–18; Grevenstafel; Ypres, 1915; St Julien; Frezenberg; and Bellewaerde.

The 3rd (Special Reserve) Battalion, previously the old Shropshire Militia, spent the First World War stationed in Wales, Scotland, and Ireland. When the war ended the 3rd was absorbed into the 2nd Battalion.

The 4th (Territorial) Battalion was raised in Shrewsbury in August 1914, later expanding to form two additional line battalions, the 2nd/4th and 3rd/4th. The 1st/4th (Territorial) Battalion KSLI formed from the County Rifle Volunteers and served in India, Hong Kong, Singapore, where it helped suppress the 1915 Singapore Mutiny, and Rangoon, also providing escort duty for German prisoners sent to Australia. Transferred to the Western Front in July 1917 after two months in South Africa, the 1st/4th Battalion, attached to the 63rd (RN) Division, saw action at the Third Battle of Ypres (Passchendaele) in October 1917, suffering 130 casualties on one day. They were also involved in the fighting around Messines in the 1918 German offensive. On 6 July 1818 the battalion took part in the capture of Bligny Hill, earning the award of the French Croix-de-Guerre avec Palm, and in October to the Somme. When the war ended the battalion was part of the 56th Brigade, 19th Division.

They were awarded fourteen Battle Honours: France and Flanders, 1917; France and Flanders, 1918; Passchendaele; Cambrai, 1917; Bapaume, 1918; Messines, 1918; Bailleul; Kemmel; Bligny; Aisne, 1918; Cambrai, 1918; Selle; Valenciennes; Sambre.

The 2nd/4th Battalion KSLI was formed at Shrewsbury in October 1914, serving on the Isle of Man and the East Coast in 1915–17. In December 1916 it became the 50th Provisional Battalion and by December 1917 all personnel had been absorbed into other battalions.

G. **R.**

YOUR

KING & COUNTRY
Need Another
100,000 MEN.

Lord Kitchener's First World War recruiting poster.

The 3rd/4th Battalion KSLI, raised in Shrewsbury in May 1915, was stationed in various towns in South Wales from 1915 to 1918. They were restyled the 4th (Reserve) Battalion in April 1916, absorbed into the 2rd Herefordshire Regiment in 1917, and disbanded at the end of the war.

In August 1914 the 5th (war-raised Service) Battalion KSLI was formed in Shrewsbury, landing at Boulogne, France, on 20 May 1915 as part of the 42nd Brigade, 14th Division, serving the entire war on the Western Front. They were involved in some of the hardest fighting at Ypres Salient in 1915, and on the Somme in 1916, also at Arras, and in the 3rd Battle of Ypres (Passchendaele) in 1917. Disbanded 4 February 1918, personnel transferring to other KSLI battalions.

They won nine Battle Honours: France and Flanders, 1915; France and Flanders, 1916; France and Flanders, 1917; Ypres, 1915; Somme, 1916; Delville Wood; Flers-Courcelette; Arras, 1917; Ypres, 1917.

The 6th (war-raised Service) Battalion KSLI was raised at Shrewsbury in September 1914, joining the 60th Brigade, 20th Division, landing Boulogne, France, on 22 July 1915, serving entirely on the Western Front. They saw action at Loos in September 1915, around Ypres in 1916, and then the Somme. In August 1917 the battalion fought at Langemarck (3rd Ypres), and in September on the Menin Road, Ypres. They also fought near Cambrai 1917, on the Hindenburg Line, and in the 1918 German spring offensive, and were disbanded in June 1919.

They won thirteen Battle Honours: France and Flanders, 1915; France and Flanders, 1916; France and Flanders, 1917; France and Flanders, 1918; Mount Sorrel; Guillemont;

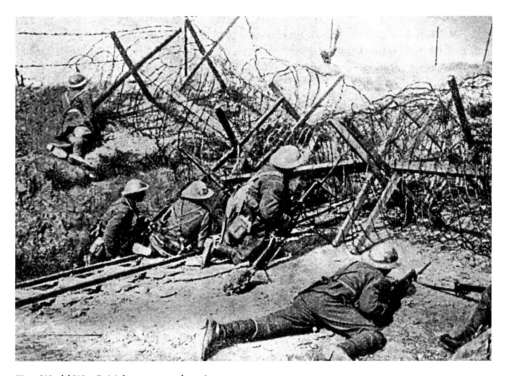

First World War British troops at the wire.

Flers-Courcelette; Le Transloy; Langemarck, 1917; Menin Road; Cambrai, 1917; St. Quentin; and Rosieres.

The 7th (war-raised Service) Battalion KSLI was formed at Shrewsbury in September 1914, joining the 76th Brigade, 25th Division, landing at Boulogne, France, in 28 September 1915, serving the entire war on the Western Front. They saw action at Ypres Salient during the winter of 1915–16, then on the Somme in July 1916. They were involved in fighting at Bazentin Ridge, Ancre, and Arras, also taking part in the three Battles of the Scarpe in April–May 1917, and in the action at Polygon Wood (3rd Ypres) in September, and the Somme in 1918. They also took part in the 1918 summer–autumn offensive at Albert, Bapaume, Canal du Nord, and the Selle, and ended the war part of the 8th Brigade, 3rd Division. They disbanded in June 1919.

They were awarded twenty-six Battle Honours: France and Flanders, 1915; France and Flanders, 1916; France and Flanders, 1917; France and Flanders, 1918; Mount Sorrel; Somme, 1916; Albert, 1916; Bazentin; Delville Wood; Arras, 1917; Scarpe, 1917; Arleux; Ypres, 1917; Polygon Wood; Somme, 1918; St. Quentin; Bapaume, 1918; Arras, 1918; Lys; Estaires; Hazebrouk; Bethune; Albert, 1918; Bapaume, 1918; Canal du Nord; and Selle.

The 8th (war-raised Service) Battalion KSLI was raised at Shrewsbury in September 1914, joining the 66th Brigade, 22nd Division, landing in France on 28 October 1915 making for Amiens, then ordered to Macedonia after only a few weeks on the Western Front, landing 6 November 1915, serving the rest of the war on the Salonika front, where the battalion suffered badly from Malaria. They were in action at Pip Ridge, near Lake Doiran, in 1917 and 1918. At the end of the war the battalion was amalgamated with the 2nd Battalion KSLI.

Battle Honours: Macedonia, 1915–18; Doiran, 1917; and Doiran, 1918.

The 9th (Reserve) Battalion KSLI was formed in October 1914 at Pembroke Dock, serving mainly in a training capacity in the UK, and from August 1915 at Prees Heath, Shropshire.

After the war the KSLI, was reduced from ten to two regular battalions, plus one Territorial – the 4th Battalion.

The 1st/KSLI subsequently served in Aden before transferring to India in 1921, where they were engaged in operations in 1930–31 near Peshawar, and against the Mahsuds in Waziristan, returning home in 1938. Meanwhile 2/KSLI travelled from Macedonia to Ireland in 1919, absorbing the 3rd (Special Reserve) Battalion.

The Second World War

At the outbreak of the Second World War the KSLI was greatly expanded.

The 1st/KSLI landed in France on 23 September 1939 as part of the 3rd Infantry Brigade, 1st Infantry Division of the ill-fated British Expeditionary Force (BEF). After advancing into Belgium in May–June 1940, the BEF was forced to fall back to Dunkirk where the battalion was one of the last to be evacuated. During this first phase of the war the battalion had the unfortunate distinction of having the very first British casualty when Corporal T. W. Priday was sadly killed near Metz on 9 December 1939.

The battalion undertook training and Home Defence duties until 1943 when it was sent to North Africa, taking a leading role in the Tunisian Campaign, in particular the

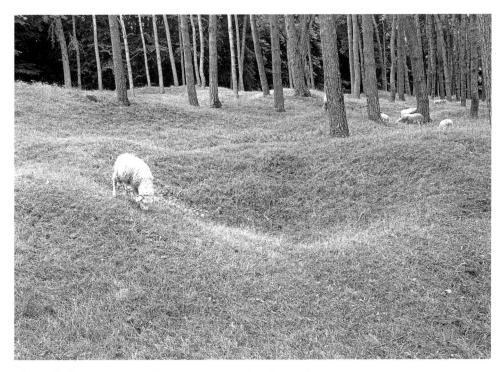

Above: Shell craters, Vimy Ridge. (Courtesy of Tricia Bennett)

Below: Vimy Ridge war memorial. (Courtesy of Tricia Bennett)

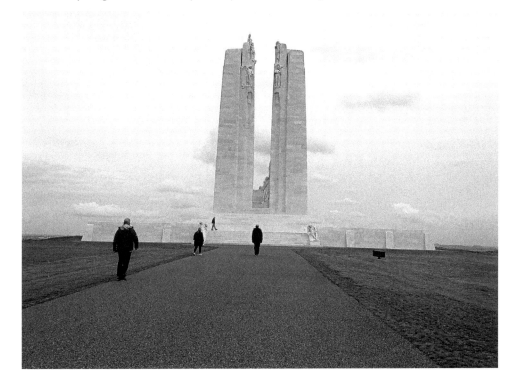

capture of Tunis and Ben Aoukaz, later involved in the capture of the Mediterranean Island of Pantellaria. At Anzio, Italy, in 1944, the 1st/KSLI took part in brutal fighting, and from there to Florence, the Arno, Borgo San Lorenzo, and Monte Ceco, a campaign of ferocious mountain battles in atrocious winter conditions. The battalion was ordered to Syria in February, and then to Nathanya in Palestine, stationed there at the end of the war in Europe. During the war the battalion suffered casualties to fifty-seven officers and 1,292 other ranks, in the process earning five DSO's, fourteen Military Crosses, two MBE's, three Distinguished Conduct Medals, twenty-seven Military Medals, two Bars to the Military Medals, and fifty-two Mentions in Dispatches.

They also won fourteen Battle Honours: Defence of Escaut; Dunkirk, 1940; North West Europe, 1940; Tunis; Gueriat el Atachi Ridge; Djebel Bou Aoukaz, 1942 (II); North Africa, 1943; Anzio; Campoleone; Gothic Line; Monte Ceco; Monte Grande; Italy, 1943–45.

When the war began 2/KSLI was stationed in Jamaica and Bermuda, moving to Curacao and Aruba to guard oil installations from May 1940 to 1942, before returning home. 2/KSLI, landed in Normandy on D=Day on 5 June 1944 as part of the 185th Infantry Brigade, 79th Armoured Division, fighting its way off the beach to Caen and Virose, and on through Belgium to Holland. The battalion saw action at Overloon, Brabander and Venraij, wintering on the River Maas (Meuse). At Kervenheim in the advance to the Rhine, Private Joseph Stokes was awarded a posthumous Victoria Cross. On 29 March 1945, the battalion crossed the Rhine, playing a part in the capture of Bremen. In the conflict 2/KSLI suffered 756 casualties, earning: one Victoria Cross, two DSO's, seven Military Crosses, one Bar to the Military Cross, one MBE, fourteen Military Medals, five Mentions in Dispatches, and three Foreign Awards.

They also won Battle Honours: Normandy Landing; Caen; Troan; Le Perier Ridge; Nederrijn; Venraij; Rhineland; Lingen; Bremen; North West Europe, 1944–45.

On 3 September 1939 the 4th (Territorial) Battalion KSLI was formed at Shrewsbury, joining the 159th Brigade, 11th Armoured Division, as a lorry-borne infantry unit, landing in Normandy on 14 June 1944, fighting over the Odon River and at Caen, Amiens, and Vimy Ridge. One of the first units of allied infantry to enter Antwerp, the 4th later protected the right flank at Arnhem and took part in the capture of Asten and Overloon, where Sergeant George Earley, M. M., was awarded the Victoria Cross. After wintering on the River Maas on 28 March 1945, the battalion crossed the Rhine and was the first British unit to reach the River Elbe. The battalion lost 259 men killed in action, earning: one Victoria Cross, three DSOs, one Bar to the DSO, nine Military Crosses, one Distinguished Conduct Medal, nineteen Military Medals, one British Empire Medal, and two Croix de Guerre.

They won thirteen Battle Honours: Odon, Bourguebus Ridge, Mount Pincon, Souleuvre, Le Perier Ridge, Falaise, Antwerp, Venraij, Rhineland, Hochwald, Ibbenburen, Aller, and North West Europe, 1944–45.

Against the threat of war with Germany the 5th Battalion KSLI was originally formed as the 2nd/4th Battalion in April 1939, renamed the 5th in September 1939, joining the 114th Brigade, 38th Welsh Division. Company 'A' was based at Cleobury Mortimer and Highley, Company 'B' at Bridgnorth, 'C' at Wellington, and 'D' at Ironbridge, all undertaking duties including home defence and training, amalgamating with the 4th Battalion on 1 January 1946.

The 6th (War Service) Battalion was formed in June 1940 for home defence, joining the 204th Independent Infantry Brigade (Home), converting to artillery as the 181st Field Regiment, Royal Artillery, in March 1942, serving as part of the 44th (Lowland) Brigade, 15th (Scottish) Infantry Division, landing in Normandy in 1944. The unit served from Normandy, through Belgium and Holland, to Germany, having the distinction of being the first artillery field regiment to cross the Rhine and the Elbe rivers. It was disbanded in January 1946.

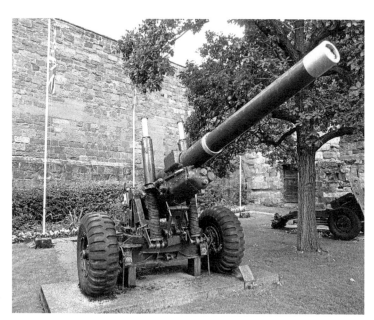

5.5-inch gun, the type used by the 75th and 76th (Shropshire Yeomanry), Medium Regiments, Royal Artillery, and 240th (Shropshire Royal Artillery) Battery of the 51st (Midland) Medium Regiment, Royal Artillery. (Courtesy of Shropshire Regimental Museum)

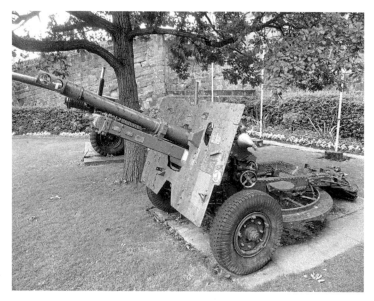

25-pounder training gun sited at Oswestry between 1938 and 1968. (Courtesy of Shropshire Regimental Museum)

The 7th (War Service) Battalion was formed in September 1940 from the 70th (Holding) Battalion at Church Stretton, serving in a home defence role at Deal, Herne Bay, and Hornsea. It was converted in November 1942 to the 99th Anti-Tank Regiment, Royal Artillery, and disbanded in December 1943.

The 8th (Home Defence) Battalion was formed specifically for a home defence role from the National Defence Companies of the Territorial Army Reserve. It started life as the 2nd/10th (Home Defence) Battalion, Liverpool Regiment, redesignated the 15th (Home Defence) Battalion, Liverpool Regiment, before again being redesignated the 8th (Home Defence) Battalion KSLI in August 1941. Its role was aerodrome protection. On 1 July 1942 became the 30th (Home Defence and Young Soldiers' Mobile) Battalion KSLI, then in November becoming the 99th Primary Training Centre. It was disbanded in September 1943.

The 20th (Holding) Battalion was formed in November 1942, stationed at Leominster in 1945, and disbanded in November 1946.

In 1948 the KSLI was reduced to one regular battalion, the 1st and 2nd regular battalions amalgamating to form one battalion to be known as the 1st/KSLL. The formal ceremony took place at Shrewsbury in 12 June 1948.

The Korean War

1/KSLI sailed from Liverpool to Hong Kong in August 1949, joining the 40th Division. From there the battalion was sent to Korea in April 1951 to fight against the Soviet-backed communists, joining the 28th Commonwealth Infantry Brigade, serving around the River Imjin, before joining the newly formed 1st Commonwealth Infantry Division. The unit

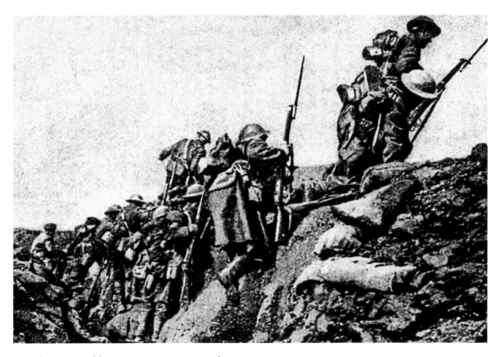

British First World War troops going over the top.

played a major role in the capture and defence of Kowang San Hill 355, C Company, beating back a fierce counter-attack. The battalion also fought at Hill 208 and 210 and in the battle for Hill 227. The KSLI returned home in 1952.

The Korean War ended in July 1953, having cost the lives of millions of soldiers and civilians. In their seventeen months in Korea sixty-two men of 1/KSLI were killed.

The battalion won the Battle Honours, Kowang San and Hill 227.

In May 1955, the regiment's bicentenary year, 1/KSLI embarked for Kenya to join the fight against the Mau Mau insurgents, also serving briefly in the Suez Crisis and in Aden while stationed in Kenya.

In 1968 the amalgamation of light infantry regiments finally drew the KSLI's existence as a county regiment to a close when it became the 3rd Battalion Light Infantry, subsequently becoming part of The Rifles.

The Shropshire Yeomanry

At Cairo on 2 March 1917 the 10th (Shropshire and Cheshire Yeomanry) Battalion KSLI was formed as infantry from the previously mounted units of the Shropshire and Cheshire Yeomanry, serving in the Middle East with the 23rd Brigade, 74th (Yeomanry) Division (also known as 'Broken Spur' from their badge, chosen by their commander as a reminder of the sacrifice by yeomen in giving up their horses), taking part in the 2nd and 3rd Battles of Gaza in July–November 1917, in the capture of Jerusalem in December 1917, and Jericho in February 1918. On 10 March 1918 the battalion took part in the attack on Burj-el-Lisaneh, near Tell 'Asur, where Private Harold Whitfield won Shropshire's only Victoria Cross of the war. The battalion transferred to France in May 1918, serving the rest of the war on the Western Front, including in the Battle of Epéhy in September.

The battalion won the following Battle Honours: France and Flanders, 1918; Palestine, 1917–18; Epéhy; Pursuit to Mons; Gaza; Jerusalem; Jerico; Tell 'Asur; Egypt, 1916–17; Somme, 1918; Bapaume, 1918; and Hindenburg Line.

4. Military Personalities

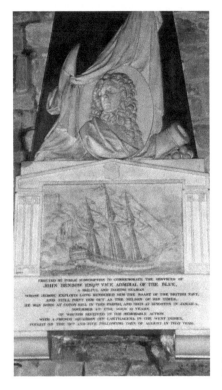

Admiral Benbow's memorial plaque, St Mary's Church, Shrewsbury.

Admiral John Benbow, 1653–1702

John Benbow's date and place of birth are widely disputed. He may have been born on 10 March 1653 in Newport, Shropshire, or at Coton Hill, Shrewsbury. His parents were William and Martha Benbow. The inscription on Benbow's tomb states that when he died in 1702 he was fifty-two years old. He attended a free school in Shrewsbury, later being apprenticed to a River Severn waterman, eventually joining the Royal Navy, rising to the rank of Admiral. Benbow achieved his fame fighting the French during the War of Spanish Succession (1701–14), where in August 1702 several captains under his command refused to support his decisions. He got his revenge on the offenders by instigating a trial against them; however, he died in Jamaica before they were punished. During an engagement with the French off Santa Marta, Benbow lost one of his legs, which caused his death but ensured his place in the list of British naval heroes.

Admiral Benbow was a popular figure in the country, his exploits celebrated in song. In Robert Louis Stevenson's book *Treasure Island* the name of Jim Hawkins' mother's inn is the Admiral Benbow. Members of Benbow's wider family include another John Benbow, a captain in the Parliamentary army during the English Civil War, who was shot on Shrewsbury Castle Green on 15 October 1651.

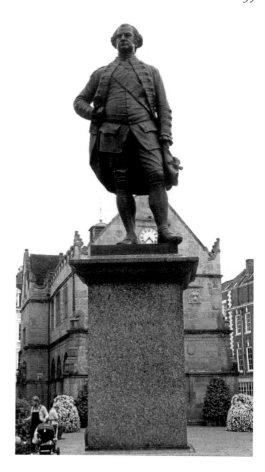

Robert Clive 'Clive of India' statue,
Shrewsbury.

Robert Clive, 1725–74

One of England's heroes, Clive of India was born 29 September at Styche Manor near
Market Drayton, the son of lawyer Richard Clive. Robert Clive is best known for his
spectacular military victories in India while employed by the East India Company,
particularly his capture of the fort and port at Arcot in 1751, and at Madras. His most
famous victory was against overwhelming odds at Plassey. In 1760 Clive returned to
England a hero, becoming MP for Shrewsbury, and was awarded an Irish peerage.
Following a series of corruption and bribery scandals in India he returned there to resolve
the situation. Back in England in 1767 he found many jealous enemies blackening his
reputation. The next few years saw him vilified by the same press that had previously
hailed him a hero. MPs called for an investigation into Clive's enormous wealth, said to
be almost £250,000.

Robert Clive died a broken man on 22 November 1774 at his house in London's Berkeley
Square. There is doubt about the exact manner of his death. Alternative rumours suggest
he slit his own throat, or that he shot himself, or that he died from an overdose of opium
as his family claimed. Clive had made two previously unsuccessful attempts at suicide
when still a young man in India – on both occasions the pistol failed to fire.

Lord Hill standing proudly at the top of the Doric column erected in his honour.

Lord Rowland Hill, 1772–1842

Born at Hawkstone Hall on 11 August 1772, Rowland Hill was educated at the King's School, Chester. Commissioned into the 38th Regiment of Foot in 1790, and thence to the 53rd Foot in 1791, Rowland served as aide-de-camp to General O'Hara at the siege of Toulon in 1793, and then commanded the 90th Foot at Aboukir Bay in Egypt where he received a serious head wound from a musket ball. Hill was promoted to brigadier in 1803, and major-general in 1805, serving under Sir John Moore at the Battle of Corunna on 16 January 1809.

Known to his men as 'Daddy Hill', he became one of Shropshire's most famous soldiers, and in the Peninsular War he was one of Wellesley's key generals; he and his troops were involved in all the major battles. Before the Battle of Albuera, Hill came down with malaria, and was forced to hand command of his troops to Sir William Beresford, recovering to lead a successful attack on the French at Arroyo dos Molinos. In February 1812 he was made a Knight of the Bath.

In 1814 when peace with France came, he was appointed Governor of Hull, also serving as MP for Shrewsbury between 1812 and 1814.

Rowland Hill commanded the 2nd Army Company at the Battle of Waterloo, narrowly escaping death while leading a charge against Bonaparte's Imperial Guard.

Hill's unstinting bravery and leadership earned him many honours at home and overseas. In 1828 he succeeded the Duke of Wellington as Commander-in-Chief, later becoming Governor of Plymouth, and in 1830 Viscount Hill of Almaraz. Lord Rowland Hill died at Hardwicke Grange, Hadnall, on 10 December 1842, and is buried in the churchyard of St Mary Magdalene's Church, Hadnall. His statue sits proudly on top of a 133-foot 6-inch- (40.7-metre-) high Doric column, one of Shrewsbury's greatest landmarks, prominently sited adjacent to the offices of Shropshire County Council.

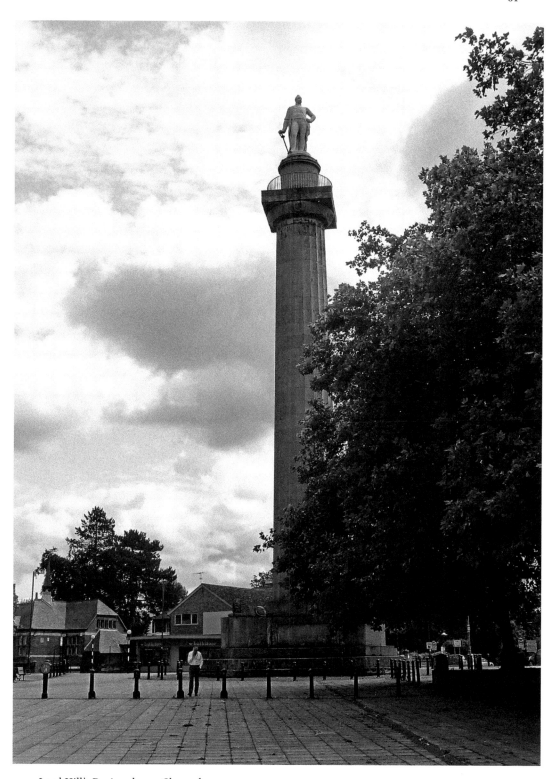

Lord Hill's Doric column, Shrewsbury.

5. Military Units

Shropshire Militia

Although the term militia was not widely used until the seventeenth century, its origins can be traced back to the Anglo-Saxon fyrd, when every able-bodied male was expected to turn out to defend their shire. The county levy, a citizen army of non-professional soldiers raised as a homeland defence force from individual parishes, came under the control and command of the sheriff of the county. From 1541 this responsibility transferred to the Lord Lieutenant of the county.

Early records suggest that Shropshire had some kind of militia in the 1580s. Trained bands of men were formed at Shrewsbury School, and against the thread of Spanish Invasion in 1588. Various volunteer militia units were formed in the early 1600s, and during the English Civil War in 1642–51.

The aim of the Militia Act of 1757 was to officially create a national professional military reserve in each county. Parishes were required to compile and publish muster rolls of able-bodied men of military age who were eligible for service. Militiamen were then selected by ballot, these non-volunteers required to undertake military service whenever they were ordered, such as in times of invasion, warfare or civil strife. Undertaking this militia service could be avoided if a replacement was provided, which of course wealthy citizens could do – i.e. paying another person to serve in their place.

A Salop Regiment of Regular Militia was formed in 1762 under the command of the Earl of Bath, and in 1795 an Artillery Company was formed to support the Shropshire Regular Militia. However, by the end of the Napoleonic Wars in 1815, only the Salop Regiment of Militia remained.

In 1852 militia service became wholly voluntary, a kind of Territorial Army.

The Shropshire Militia was called up (embodied) for service at times of national emergency, such as:

The Seven Years' War, 1763–66.
The American Revolutionary War, 1775–83.
The French Revolutionary Wars (including Wars of the First and Second Coalitions), 1793–1802.
The Napoleonic Wars (including Wars of the Third, Fourth, Fifth, Sixth and Seventh Coalitions), 1803–15.
The Crimean War, 1853–56.
The Indian Mutiny, 1857–58.

Portrait of William Whitmore, founder of the 53rd Regiment of Foot. (Courtesy of Shropshire Regimental Museum)

The 53rd Regiment of Foot

In December 1755 William Whitmore of Apley, near Bridgnorth, serving at that time as an officer in the 3rd Foot Guards, was ordered to raise a new regiment. With Whitmore as its colonel, the new regiment was first designated the 55th Regiment of Foot. The following year, after the two colonial regiments the 50th (American Provincials) and the 51st (Cape Breton Regiment) were disbanded, the 55th was renumbered the 53rd Regiment of Foot.

William Whitmore was born 14 May 1714, joining the army, and rising to the rank of lieutenant-general in 1760. In 1758 he transferred to the 9th Regiment of Foot as colonel. One of Lord Powis' Shropshire Whigs, Whitmore served as MP for Bridgnorth from 1741 to 1747, and again from 1754 to 1771. He died at Lower Slaughter, Gloucestershire, on 22 July 1771 at the age of fifty-seven.

Confusion sometimes arises regarding the regimental numbering around this time regarding the 55th because this number was reallocated to the 57th Westmorland Regiment at the same time the 55th were renumbered the 53rd.

The uniform of the 53rd was a red uniform jacket with red facings, resulting in the regiment's common nickname of the 'Brickdusts'. Other nicknames include the 'Old Five and Threepennies' from its 53 number, the 'Honeysuckers', a nickname earned during the Peninsular War after some of its soldiers were flogged for disobeying Sir Arthur Wellesley's orders not to steal honey from the locals. The other nickname was the 'Red Regiment', the nickname given to the regiment by the exiled Napoleon Bonaparte when acting as his guard on St Helena. Soldiers of the 53rd in the eighteenth century wore a tricorne hat, which in the early nineteenth century was replaced by the shako. At the end of the nineteenth century the shako was replaced by the official pith service helmet.

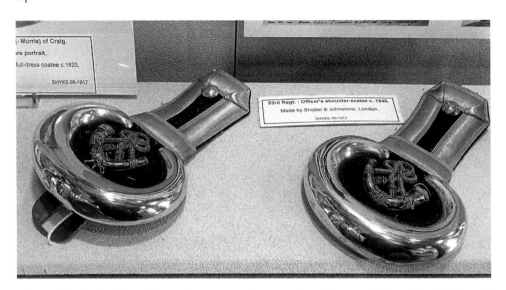

Above: Officer's shoulder scales, 53rd Regiment of Foot, *c.* 1840. (Courtesy of Shropshire Regimental Museum)

Below: Officer's shako plate, 53rd Regiment of Foot, 1844–45. (Courtesy of Shropshire Regimental Museum)

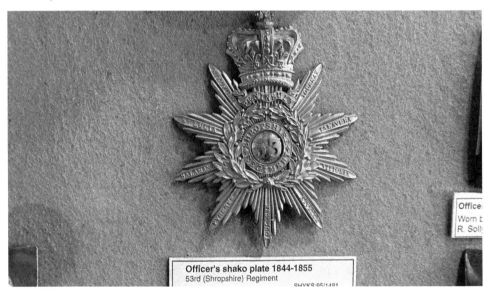

The Cardwell Reforms of the 1870s recommended that single-battalion regiments be linked together to share a common depot and recruitment district. Assigned to the 21st District at Copthorne Barracks, the 53rd was thus linked with the 43rd (Monmouthshire) Regiment of Foot.

The 1881 Childers Reforms saw the 85th (King's Light Infantry) Regiment change places with the 43rd to form the King's Shropshire Light Infantry with the 53rd.

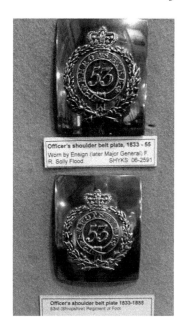

Right: Officer's shoulder belt plates, 53rd Regiment of Foot, 1833–55. (Courtesy of Shropshire Regimental Museum)

Below: Two officer's shoulder belt plates, 1st and 2nd Shropshire Militia, 1794. (Courtesy of Shropshire Regimental Museum)

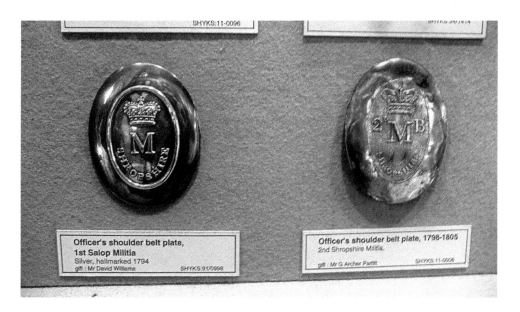

The 85th Regiment of Foot

Raised as the Royal Volontiers (spelled with an o) in 1759, its first rendezvous was at Shrewsbury Castle; this was the first light infantry regiment to be formed in the British Army. Its first colours were presented on 21 December 1759 and ceremonially carried to St Chad's Church, Shrewsbury. Soon after formation the regiment moved to Newcastle-upon-Tyne. The uniform was red coats with no lapels, blue cuffs and white capes, white breeches, cocked hats with narrow white lace, and a plume of white feathers,

plus black leather gaiters. The regiment's first colonel was John Craufurd. The 85th saw action in the Seven Years' War (1756–63) before being disbanded in 1763. The regimental number was subsequently reused for the 85th Westminster Volunteers (1779–83), and the 85th Bucks Volunteers (1793–1821), converting to light infantry in 1808. Restyled the 85th (Duke of York's Light Infantry) in 1815, before in 1821 it was restyled the 85th (the King's Light Infantry) Regiment until 1881, when amalgamating with the 53rd to form the King's Shropshire Light Infantry.

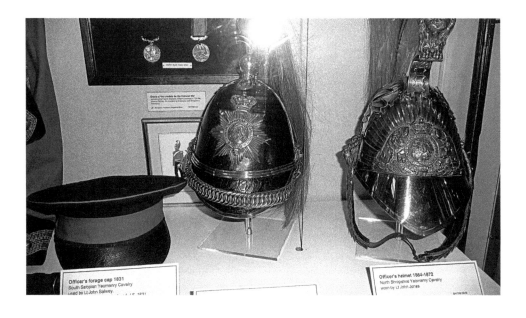

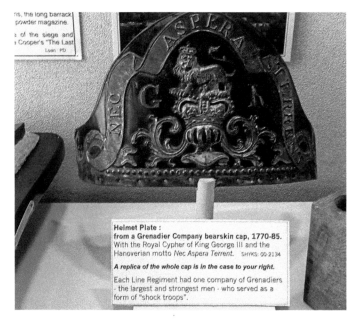

Above: Officer's forage cap, 1831, and officer's helmets, 1816–37 and 1864–72, Shropshire Yeomanry. (Courtesy of Shropshire Regimental Museum)

Left: Helmet plate from a grenadier company bearskin cap, 1770–85. (Courtesy of Shropshire Regimental Museum)

The 86th (Shropshire) Regiment

Originally raised at Shrewsbury in 1793 as Sir Cornelius Cuyler's Shropshire Volunteers, recruiting men from Cheshire, Lancashire, and Yorkshire, in 1794 it become the 86th (the Shropshire Volunteers) Regiment of Foot, and in 1795 was absorbed into the 118th Regiment of the British Army. In 1806 the 86th became the 86th (Leinster) Regiment of Foot, then six years later was renamed the 86th (Royal County Down) Regiment of Foot.

The Shropshire Yeomanry

The Shropshire Yeomanry were originally formed in 1795 during the French Wars of 1793–1815, in 1795 the Wellington Troop being the first raised. At the end of the French Wars the yeomanry was consolidated into three regiments: the Shrewsbury Yeomanry Cavalry, the South Shropshire Yeomanry Cavalry and the North Shropshire Yeomanry Cavalry. These units were clothed and trained as dragoons (mounted infantry) in 1814. In 1828, the South Shropshire Yeomanry Cavalry absorbed the Shrewsbury Yeomanry Cavalry. Then in 1872 the South Salopian Yeomanry Cavalry and the North Salopian Yeomanry Cavalry amalgamated to form the Shropshire Yeomanry Cavalry, serving in South Africa in 1900.

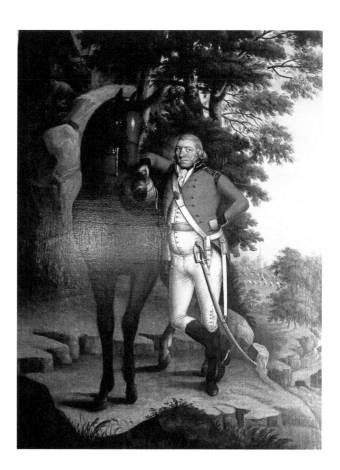

Portrait of Lt-Colonel William Cludde, Shropshire Yeomanry Cavalry, c. 1795. (Courtesy of Shropshire Regimental Museum)

Diagram showing the development of the Shropshire Yeomanry Cavalry.

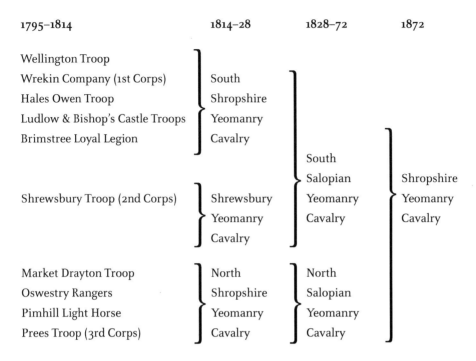

1795–1814	1814–28	1828–72	1872
Wellington Troop			
Wrekin Company (1st Corps)	South		
Hales Owen Troop	Shropshire		
Ludlow & Bishop's Castle Troops	Yeomanry		
Brimstree Loyal Legion	Cavalry		
		South	
		Salopian	Shropshire
Shrewsbury Troop (2nd Corps)	Shrewsbury	Yeomanry	Yeomanry
	Yeomanry	Cavalry	Cavalry
	Cavalry		
Market Drayton Troop	North	North	
Oswestry Rangers	Shropshire	Salopian	
Pimhill Light Horse	Yeomanry	Yeomanry	
Prees Troop (3rd Corps)	Cavalry	Cavalry	

Volunteers from the regiment formed the 13th (Shropshire) Company of the 5th Battalion Imperial Yeomanry. Although not intended for service overseas, mounted units were necessary in the Boer War to combat the fast-moving enemy, so the British government allowed volunteers to serve in South Africa. Around 240 Yeomen served during the campaign, earning the first Shropshire Yeomanry Battle Honour: South Africa (1900–02).

In 1908 on the creation of the Territorial Force, the regiment came under the auspices of the Welsh Border Mounted Brigade with four squadrons:

Squadron	Headquarters	Drill Stations at:
'A'	Shrewsbury	Baschurch, Pontesbury, Pulverbach, and Wem.
'B'	Oswestry	Whitchurch and Ellesmere.
'C'	Ludlow	Craven Arms, Ross on Wye, Hereford, Leominster, Tenbury and Kington.
'D'	Wellington	Much Wenlock, Shifnal, Market Drayton, Newport and Bridgnorth.

During the First World War the Shropshire Yeomanry was expanded to form three units. The 1/1st Shropshire Yeomanry Brigade served initially with the East Coast Home Defence Force, and in November 1915 became a dismounted unit, sailing to Egypt in March 1916 to merge with other units, fighting in the Senussi Campaign in Egypt's Western Desert, and later against the Turks in Palestine. In March 1917 they merged with the 1/1st Cheshire Yeomanry, the unit becoming the 10th Battalion King's Shropshire Light

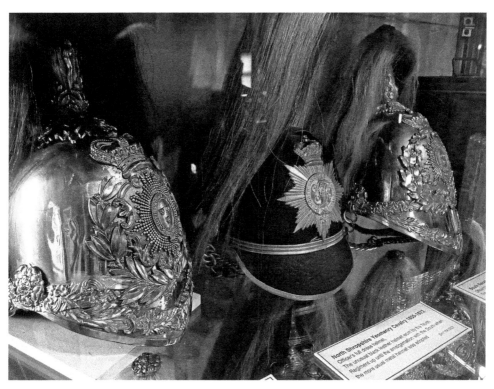

Officer's full dress helmets (from left to right): South Salopian Yeomanry Cavalry, 1953–72; North Shropshire Yeomanry Cavalry, 1855-72; and South Salopian Yeomanry Cavalry, 1853-72. (Courtesy of Shropshire Regimental Museum)

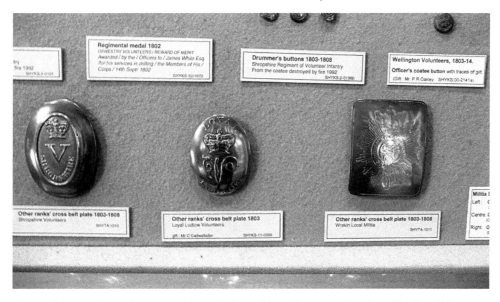

Three other ranks' cross belt plates, 1803-08: Shropshire Volunteers, 1803; Loyal Ludlow Volunteers, 1803-08; and Wrekin Local Militia. (Courtesy of Shropshire Regimental Museum)

Infantry, 231st Brigade, 74th (Yeomanry) Division. 10/KSLI fought in the Second and Third Battles of Gaza in 1917, and the Battle of Beersheba in 1917, and were transferred to the Western Front, fighting at the Battle of Epéhy in 1918.

The 2/1st Shropshire Yeomanry was formed in 1914, first serving in Northumberland and then East Anglia. It was later renamed 17th Mounted Brigade, returning to Northumberland where it converted to the 10th Cyclist Brigade. It was renamed 6th Cyclist Brigade in March 1917, moving to Ireland in early 1918, amd disbanded later that year.

The 3/1st Shropshire Yeomanry was formed as part of a Reserve Cavalry Regiment in 1915, remaining in England until being disbanded in early 1917.

During the Second World War the regiment converted to artillery: the 75th and the 76th (Shropshire Yeomanry) Medium Regiments, Royal Artillery, both serving in North Africa and Italy. The regiment was disbanded at the end of the war, the men reverting to the Shropshire Yeomanry.

The Shropshire Yeomanry survived until 1971, when it was expanded to form the Shropshire Yeomanry Squadron of the Mercian (later the Queen's Own Mercian) Yeomanry, subsequently absorbed into the Royal Mercian and Lancastrian Yeomanry.

The Shropshire Volunteers
The Brimstree Loyal Legion.
Oswestry Rangers.
Pimhill Light Horse.
Wellington Fencibles.
Plus Loyal Infantry Units at Cleobury Mortimer, Ludlow; Newport; Shrewsbury; Wenlock; Whitchurch; Morfe; and Royal Oak.

Two swords: on the left is Rifle Volunteers bandsman's sword, c. 1860, and on the right is Infantry or Militia soldier's hangar or short sword, c. 1760–1800. (Courtesy of Shropshire Regimental Museum)

All types of volunteer home guard units, comprising cavalry, infantry and artillery, raised against the threat of invasion during the French Revolutionary War (1793–97), and continuing service through the Napoleonic Wars (1799–1815).

The Oswestry Volunteer Infantry, formed in 1803, converted to artillery in 1804. The first volunteer Shropshire Artillery Company was formed in 1795 as part of the Shropshire Regular Militia. At the end of the war in 1815 all units were disbanded.

Shropshire Volunteer Rifle Companies

The Shropshire Volunteer Rifle Companies were raised as eighteen local defence units of 100 to 120 men between 1859 and 1860 amid fears of a French invasion, and divided into two administrative battalions for organisational, training and pay purposes.

The 1st Administrative Battalion included:

1st (Shrewsbury)
4th (Bridgnorth)
5th (Condover)
6th (Ironbridge)
9th (Shrewsbury). Converted to artillery in March 1860, renamed 1st Shropshire Volunteer
 Artillery Corps, becoming the Shropshire Artillery Volunteers that same year.
10th (Ludlow)
11th (Cleobury Mortimer)
14th (Shifnal)
17th (Shrewsbury).

The 2nd Administrative Battalion included:

2nd (Market Drayton)
3rd (Whitchurch)
7th (Wellington)
8th (Hodnet)
12th (Wem)
13th (Ellesmere), disbanded 1879, reformed 1885
15th (Oswestry)
16th (Munslow), disbanded in 1863
18th (Newport).

In 1880 these two administrative battalions (sixteen remaining companies) were renamed the 1st and 2nd Shropshire Rifle Volunteer Corps respectively. Following the Childers Reforms of 1881, both were amalgamated into the King's Light Infantry (Shropshire Regiment) as the 1st and 2nd (Volunteer) Battalions (VSCs), both serving in South Africa during the Boer War, in the main alongside 2/KSLI, the 1st/VSC serving in 1900–01, and the 2nd/VSC serving in 1901–02. In 1908 these volunteer battalions became the 4th (Territorial) Battalion KSLI. Battle Honour: South Africa, 1900–02.

Wall plaque, 1st Shropshire & Staffordshire Artillery Volunteers, Wellington Drill Hall.

The 1st Shropshire Volunteer Artillery Corps (AVC)

Formed in 1860 from the 9th (Shrewsbury) Volunteer Rifle Corps, the AVC amalgamated with the 1st Staffordshire Volunteer Artillery Corps and the 1st Worcestershire Volunteer Artillery Corps in 1869. (The Worcesters later left and joined with the Warwicks.) In 1880 the 1st Shropshire Volunteer Artillery Corps and the 1st Staffordshire Volunteer Artillery Corps were consolidated into one unit renamed the 1st Shropshire & Staffordshire Artillery Volunteers. They were renamed again in 1902 – the 1st Shropshire & Staffordshire Royal Garrison Artillery Volunteers.

The 1907 Territorial and Reserve Forces Act saw the formation of the Shropshire Royal Horse Artillery (Territorial Force) from the Shropshire Battery with its HQ at Shrewsbury, equipped with four German-made Ehrhardt 15-pounder guns, part of the new Welsh Border Mounted Brigade of Yeomanry, intended for service at home.

With the outbreak of war in 1914, Territorial units were split into two, the 1st Line unit for possible service overseas, the 2nd Line unit for service at home. Embodied on 4 August 1914, the 1st Line Battery (1/1st SRHA) served on the east coast, joining the 1st Mounted Division in September, re-equipped with four 18-pounder guns in December 1915, and restyled 'A' Battery, 293 Brigade, Royal Field Artillery (Territorial Force), 58th Division in August 1916. The brigade landed at Le Havre on 22 January 1917, now with two batteries of six 18-pounders plus one battery of four 4.5-inch Howitzers, serving the rest of the war on the Western Front.

The Shropshire (Reserve) Battery, Royal Horse Artillery, later restyled 2/1st Shropshire Battery (RHA), served first in Northumberland, joining the 158th Brigade, Royal Field Artillery, in April 1917, via the 1st Mounted Division, armed now with 18-pounders. The brigade landed at Boulogne on 24 May 1917, were redesignated 'A' Battery, 158 Brigade, Royal Field Artillery, and served out the war on the Western Front.

In February 1920 the unit was reconstituted into the Territorial Force as the Shropshire Royal Garrison Artillery, later renumbered the 240th (Shrops. H.R.A) (Howitzer) Medium Battery, Royal Artillery, 60th Medium Brigade, R.A. (Territorial Army), regaining the designation 240th (Shropshire RHA) Medium Battery, Royal Artillery (Territorial Army), in January 1927.

At the start of the Second World War the 240th joined the 51st (Midland) Medium Regiment, Royal Artillery (Territorial Army), now equipped with 6-inch Howitzers. Part of the British Expeditionary Force, landing in France in February 1940, they served on the Maginot Line then the Somme, returning home in June 1940 to form three coastal defence batteries during the Battle of Britain.

In October 1942 the battery landed in Egypt, and was re-equipped with 4.5-inch Howitzers in January 1943, fighting as part of the famous 8th Army in Tunisia in the Battles of Mareth, Wadi Akarit, and Enfidaville. In October of that year, now with the 5th Army, the battery served at Salerno, Italy, in the Battle of the River Voltumo, and in January 1944 in the first Battle of Monte Cassino (often called the Battle for Rome). The battery briefly rejoined the 8th Army for the Battle of the River Sangro, returning to the 5th Army for the continuance of the Battle of Monte Cassino, around the River Garigiano (the confluence of the Gari and the Liri rivers), which was at the centre of the 100-mile-long Gustav Line, the German defensive system stretching from the Tyrrhenian Sea in the west to the Adriatic coast in the east. The Third Battle of Monte Cassino in mid-March 1944 was preceded by a thunderous artillery barrage from 900 Allied guns together with a massive aerial bombardment. The abbey was finally captured on 17 May 1944. The Monte Cassino engagement was among the longest and bloodiest of the Italian Campaign.

From Italy the battery was posted to Germany as part of the 34 Armoured Brigade in Westphalia, remaining there until the war ended.

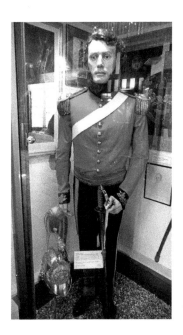

Replica uniform of an officer of the North Shropshire Yeomanry Cavalry, 1841–55. (Courtesy of Shropshire Regimental Museum)

In 1947 on the reformation of the Territorial Army, the battery joined 639 Heavy Regiment, and in 1961 became the Territorial unit of HQ Royal Artillery, 48th Division (Territorial Army), amalgamating with the Shropshire Yeomanry in 1967, becoming 'A' Squadron.

The King's Light Infantry (Shropshire Regiment)

Formed on 1 July 1881 following the Childers Reforms, the King's Light Infantry became the county regiment of Herefordshire and Shropshire following the amalgamation of the 53rd (Shropshire) Regiment of Foot and the 85th (King's Light Infantry) Regiment of Foot, which subsequently became the regular 1st and 2nd Battalions respectively.

Local militia and volunteer units were also amalgamated in the reforms: the Shropshire Militia became the 3rd (Militia) Battalion, the Royal Herefordshire Militia became the 4th (Militia) Battalion, the 1st Shropshire Rifle Volunteer Corps became the 1st (Volunteer) Battalion, and the 2nd Shropshire Rifle Volunteer Corps became the 2nd (Volunteer) Battalion. The 1st Herefordshire (Herefordshire and Radnorshire) Rifle Volunteer Corps was also amalgamated as a volunteer battalion.

In 1882 the new regiment was renamed the King's Shropshire Light Infantry (KSLI). The Regimental Depot was Copthorne Barracks in Shrewsbury.

The regiment is commemorated in A. E. Houseman's poem '1887' from the book *A Shropshire Lad*.

The King's Shropshire Light Infantry (KSLI)

The 1/1st KSLI served in India and the UK throughout the First World War. In the Second World War the battalion served with distinction in France, Africa and Italy. After the war the battalion served in the Middle East, amalgamating with the 2nd Battalion in 1948.

The 2/1st KSLI served in the South African War, in India, and in the First World War in France and the Balkans, then Ireland, Germany and the West Indies. In the Second World War they served in France and Germany, and after the war in the Middle East, until amalgamating with the 1st Battalion in 1948.

Following the amalgamation, the KSLI served in the Far East, the Korean War, then in Kenya and the Middle East, Germany, UK, Malaysia and Mauritius, until the amalgamation of light infantry units in 1968, when the KSLI became the 3rd Battalion, the Light Infantry Regiment.

In 1970 the last colours of the 1st Battalion were laid up in St Leonard's Church, Bridgnorth, by a detachment of the 3rd Battalion, the Light Infantry.

The 3rd Battalion served in Malaya, UK, Germany, Cyprus, and Ireland and were renumbered the 2nd Battalion, the Light Infantry, in February 1993, serving in UK, Ireland, Bosnia, Sierra Leone, the Falklands and Iraq. Renamed 3rd Battalion, The Rifles, they served in the UK, Iraq and Afghanistan.

As part of The Rifles, the KSLI continues to give brave service to the United Kingdom.

6. Buildings

Castles and Fortifications

Shropshire has more than its fair share of fortifications, but today many are not much to look at (arguably over thirty castles, numerous mottes, plus at least twenty-five hillforts). We also have two dykes: Offa's Dyke, built by King Offa in the eighth century, probably to keep the Welsh princes at bay (the longest archaeological monument in Britain); and the ancient Wat's Dyke.

Shrewsbury Castle was originally built by Roger de Montgomery, Earl of Shrewsbury, in 1070 on the site of an earlier Anglo-Saxon fortification, to guard the open end of a loop in the River Severn. Today it houses the most wonderful collection of memorabilia in the Shrophire Regimental Museum, which is certainly worth a visit. The website has a great deal of fascinating information about the regiments of Shropshire (http://shropshireregimentalmuseum.co.uk).

Here's a brief list of some other castles in Shropshire:

Acton Burnell Castle: Building of the red-sandstone structure is believed to have started in 1283 by Robert Burnell, Chancellor of England and a personal friend of Edward I.

Bridgnorth Castle: The ruins of the 70-foot-high, twelfth-century Norman keep of Bridgnorth Castle leans over at an angle of 15 degrees, three times more than the leaning tower of Pisa.

Clun Castle: The original Norman, timber, motte-and-bailey-style castle was built sometime around 1100 by Robert 'Picot' de Say (de Sai), on land owned by Edric Silvaticus (Edric the Wild).

Hopton Castle: Originally a Norman, timber, motte-and-bailey construction, built sometime after the Norman invasion by Walter de Hopton. It was the scene of a bloody episode during the English Civil War.

Ludlow Castle: Construction began in the late eleventh century as the border stronghold of Marcher Lord Roger De Lacy.

Moreton Corbet Castle: Originally built around 1200, this ornate ruin near Shawbury Military Base was remodelled in the sixteenth century by the Corbet family.

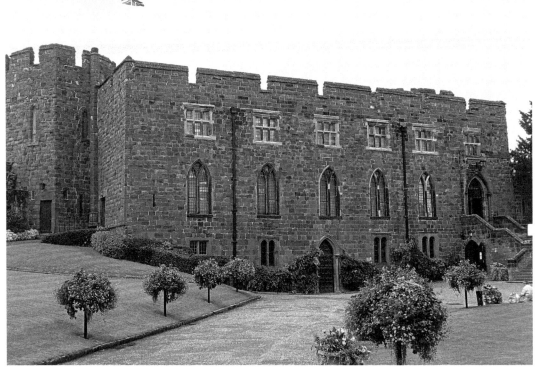

Shropshire Regimental Museum, Shrewsbury Castle. (Courtesy of Shropshire Regimental Museum)

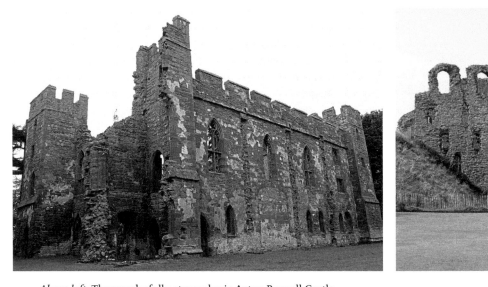

Above left: The wonderfully atmospheric Acton Burnell Castle.

Above right: The ruins of eleventh-century Clun Castle.

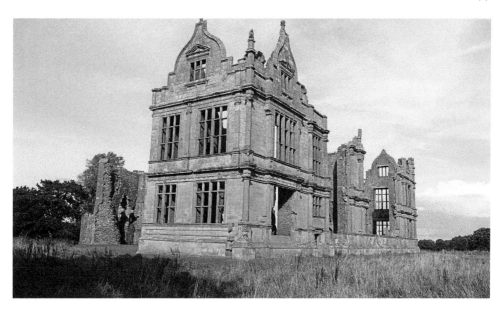

Above: The ruins of Moreton
Corbet Castle.

Right: The gatehouse of
Whittington Castle.

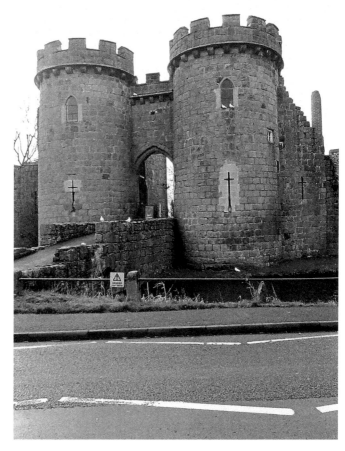

Ruyton-XI-Towns Castle: Believed to have been built by John de Strange sometime in the twelfth century.

Stokesay Castle: Not strictly a castle in the truest sense, it is more a fortified manor house.

Whittington Castle: Built by the Normans sometime after the Domesday Book, the first mention of a castle at Whittington is in 1138.

Barracks and Depots

Over the years regiments associated with Shropshire have utilised many barracks and depots. Here are the main ones:

The Armoury

Built in 1806, the Armoury was to become known as a bit of a white elephant. This lovely building standing today at Victoria Quay near Shrewsbury's Welsh Bridge is now a popular restaurant where few diners realise its curious history, or that the building was moved to this site from its original position between London Road and Wenlock Road.

Henry Grey Bennet, controversial younger son of the Earl of Tankerville and MP for Shrewsbury, instigated the construction of the Armoury at a cost of around £10,000, and was designed by James Wyatt to store up to 25,000 pieces of ordnance, muskets etc. of local volunteer militias. The site included two gunpowder stores, plus a few outbuildings. Interestingly, the land on which the Armoury was to be built was sold to the Crown for £400 by the Tankervilles.

The project was scorned by local military men who said it was too far from military barracks to be defended. Also with most of the local militia units away at the Napoleonic Wars there was no need to store their weapons. They were proved right because very

The Armoury, Victoria Quay, Shrewsbury.

Copthorne Barracks, Shrewsbury.

few weapons were ever stored there. Ironically, at the end of the war the Shropshire Militia paid £45 per year to store their weapons in Shrewsbury's Market Hall. In 1827, renowned ironmaster William Hazledine purchased the building for £2,700, renting out other buildings for housing, the armoury itself remaining empty. In 1835, Hazledine sold the armoury to Lord Berwick for £3,292. His grand plan was to convert the armoury building into luxury accommodation for customers paying to take the waters at his nearby Sutton Spa (another white elephant because unfortunately the flow of the salty, iron-flavoured water was never fast enough to make Sutton Spa a going concern despite large investments being made in the project). The armoury remained unused until Shropshire Assizes bought it for £5,000, curiously for the use of the Shropshire Militia, who stayed until they moved to new barracks at Copthorne. Over the next thirty years the armoury building was used for musical entertainments. Then in 1914, the building was used to house Belgian refugees of the First World War.

After the war, and with a shortage of building materials, the building was purchased by Morris' Bakery, who demolished the building and moved it brick by brick to its current home at Victoria Quay. The Armoury was converted to a restaurant in 1995.

Copthorne Barracks

Following the Cardwell Army Reforms in the 1870s when a number of centralised military depots were introduced, known as the Brigade Depot System, land was purchased in the Copthorne area of Shrewsbury on which to build a new barracks to house the following units of the 21st Brigade:

The 43rd Regiment of Foot (Monmouthshire Light Infantry)
The 53rd (Shropshire) Regiment of Foot

Wellington Drill
Hall, King Street.

The 54th (Shropshire) Militia
The 57th (Royal Montgomery Militia) Rifles
The 48th (1st & 2nd Administration Battalions, Shropshire) Rifle Volunteers

Copthorne Barracks cost around £65,000 to build and construction was completed in 1879. The barrack blocks were 'Sutlej', named after the battle, and 'McLeod', named after the commanding officer of the 43rd killed in Spain in 1812. Sadly Copthorne Barracks' existence as an army base is almost at an end; the site will be developed for alternative use.

Others

Shropshire also boasted numerous drill halls, sadly many long since demolished.

The MOD depot at Trench/Donnington, Telford, was once one of the largest in the UK. It is now the depot for 123 Supply Squadron 159 Regiment RLC (Royal Logistic Corps). Also based there is 159 Field Company Detached Platoon REME.

Clive Barracks, Ternhill, currently houses the 1st Battalion, the Royal Irish Regiment.

Air Force

Shropshire has operational RAF bases at RAF Shawbury and RAF Cosford, both training bases. Also the MOD still own Ternhill airfield, now a relief landing ground for the Defence Helicopter Flying School of RAF Shawbury.

During the Second World War the county was littered with operational RAF airfields.

Ships

A number of ships have borne a name associated with our landlocked county – HMS *Shropshire*. Three ships have borne the name of the county town – HMS *Shrewsbury* – plus one named HMS *Shrewsbury Castle*. Three ships have proudly carried the name HMS *Ludlow*, and two ships have borne the name HMS *Ludlow Castle*. Nine ships have been named after the River Severn – HMS *Severn*.

7. Honours and Awards

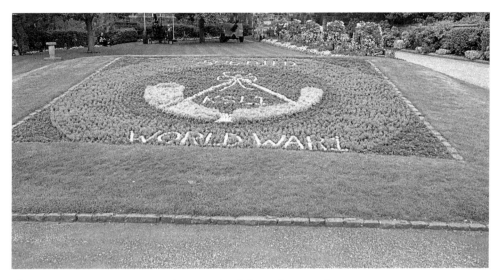

Floral war memorial, 1914–18, in the grounds of Shrewsbury Castle.

Shropshire Victoria Crosses

There are four Shropshire-born holders of the Victoria Cross, Britain's highest medal for bravery. Five others have won the VC while serving in Shropshire regiments. Additionally two former pupils of Shrewsbury school have been awarded this honour.

Sergeant Denis Dynan VC was born in Ireland in 1822, enlisting in the 44th Regiment of Foot on 8 September 1841, transferring to the 53rd Regiment on 1 July 1844, seeing action in the First Sikh War (the 1845–46 Sutlej Campaign), and Second Sikh War, (the 1848–49 Punjab Campaign).

In May 1857 when the Indian Mutiny began, the 53rd was stationed at Fort William, Calcutta. The Hazaribagh Commissioner Captain Dalton, fearing a major attack, sent for reinforcements, and the 53rd Regiment arrived in September. Learning that the mutineers' camp was around 35 miles from Hazaribagh, near Chattra, Major English led 180 men of the 53rd, plus around 150 Sikh's of the 11th Bengal Infantry, supported by two field guns, to Chattra, arriving early on 2 October 1857. Despite being faced by around 3,000 rebels, Major English attacked immediately, and after fierce hand-to-hand fighting the mutineers were driven back. Two of the enemy's four guns were destroyed by artillery fire; however, the two other guns continued to pour out a murderous fire of grapeshot at close range. Lieutenant Daunt of the 11th Bengal Infantry and Corporal Dynan of the 53rd made a direct attack on the two guns, capturing both and shooting the gun crew dead. In the action forty-two men were killed or wounded. Boxes of treasure were captured, along with forty cartloads of ammunition, ten elephants, and twenty teams of gun bullocks.

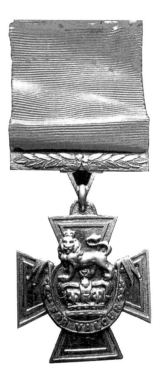

Left: Victoria Cross.

Below: First World War medals.

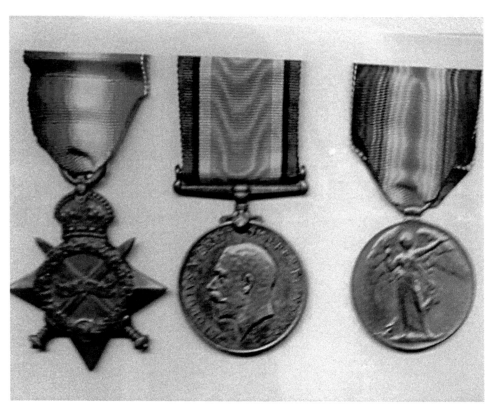

Following this victory the 53rd joined Sir Colin Campbell's force, playing a major role in the relief of Lucknow and the subsequent recapture of the city.

Denis Dynan was promoted sergeant in July 1858, serving in the 53rd until his discharge in February 1861 on the regiment's return to England. Dynan was admitted to the Royal Military Hospital in Kilmainham, Dublin, suffering from pulmonary and hepatic disease. He was discharged on 1 June 1862. There is no record of his grave; however, it is believed he died on 16 February 1863 in Dublin. His Victoria Cross was sold by Sothebys on 7 July 1998 for £20,000, and is now housed in the Ashcroft VC collection.

*

During the 1857 Indian Mutiny, three men of the 53rd were awarded the VC for their bravery during the assault on the fortified villa Sikander Bagh, Lucknow, India, on 16 November 1857, plus one man for the action on the following day. All four were nominated by the terms of Clause 13 of the VC Warrant, via a ballot of the officers and men of the regiment.

A company of the 53rd, together with a troop of Bengal Horse Artillery and cavalry, formed the advanced guard for the assault, crossing a dry canal before moving along a narrow lane bordered by thickly wooded enclosures. Turning onto a road running parallel to the Sikander Bagh, they came under intense fire. In a desperate situation, their flank exposed, the 53rd, in skirmish order, took cover while an artillery troop struggled up the steep embankment at the side of the road, unlimbered and opened fire. The heavy bombardment from their two 18-pounders punctured a hole in the wall through which the 53rd Regiment, together with the 93rd Highlanders and the 4th Punjab Infantry, supported by a battalion of detachments, raced to the successful attack. In the action the 53rd lost seventy-six men killed or wounded, the 93rd lost two officers and twenty men killed, plus seven officers and sixty-one men wounded, and the 4th Punjabis lost two out of four officers killed and one wounded, plus sixty-nine men killed or wounded. Around 2,000 rebels were reportedly killed.

Lieutenant A. Kirke Ffrench's Victoria Cross.
(Courtesy of Shropshire Regimental Museum)

Lieutenant Alfred Kirke Ffrench VC was born on 25 February 1835 in Meerut, India. Young Ffrench followed his father, a lieutenant-colonel in the 53rd, into the regiment, first as ensign, then lieutenant. At Sikander Bagh, Lieutenant Ffrench, commanding a grenadier company, was one of the first to enter the buildings. His bravery earned him the VC.

French was promoted captain on 3 September 1863. His VC is housed in the regimental collection in Shrewsbury Castle. He died at Chiswick on 28th December 1872, and is buried in a family plot in Brompton cemetery.

<p style="text-align:center">*</p>

Private James Kenny VC is believed to have been born in Dublin in 1824. Kenny was cited for conspicuous bravery, and for volunteering to bring up ammunition to his company under a very severe crossfire.

Kenny chose to stay in India when the 53rd returned to England in 1861, transferring first to the 6th Bengal European Fusiliers, then to the 101st Regiment (later Royal Munster Fusiliers). He died of disease at Multan in the Punjab in October 1862, and was buried in the European cemetery there.

<p style="text-align:center">*</p>

Private Charles Irwin VC was born in Manorhamilton, Leitrim, Ireland, in 1824, enlisting in the 18th (Royal Irish) at Sligo on 4 September 1842, serving in the Burma Campaign in 1852/53, before transferring to the 53rd Regiment. Despite being severely wounded in the right shoulder, and under heavy fire, Private Irwin was one of the first to enter the buildings.

Charles Irwin elected to stay in India, volunteering for service with the 87th Regiment (Royal Irish Fusiliers) in Hong Kong. He died on 8 April 1873, aged forty-nine, in Newton

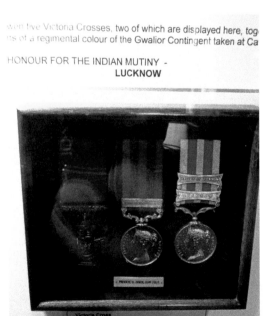

won five Victoria Crosses, two of which are displayed here, tog
ns of a regimental colour of the Gwalior Contingent taken at Ca

HONOUR FOR THE INDIAN MUTINY -
LUCKNOW

Private Charles Irwin's Victoria Cross, his India General Service medal (1854–95), and his Indian Mutiny medal. (Courtesy of Shropshire Regimental Museum)

Butler, Fermanagh, and is buried in St Mark's Churchyard, Magheraveely, Co. Fermanagh. His Victoria Cross is housed in the regimental collection of the Kings Shropshire Light Infantry in Shrewsbury Castle, together with his other campaign medals.

*

Sergeant-Major Charles Pye VC was born on 24 September 1820 at Rickerscote, Staffordshire, enlisting in the 40th Regiment in Coventry on 18 November 1840, serving in India before transferring to the 21st Foot, and from there to the 53rd.

The strongly fortified Mess House near the Sikander Bagh was a building of considerable size, surrounded by a loop-holed mud wall covering a ditch around 12 feet broad, scarped with masonry, the ditch traversed by drawbridges. On 17 November 1857, Captain Hopkins led sixty men of the 53rd, including Charles Pye together with a company of the 90th Foot commanded by Captain Wolseley at a fast pace under intense fire, reaching the mud wall before dashing across a drawbridge and entering the Mess House. Charles Pye's steadiness and fearless conduct under fire when bringing up ammunition during the fighting earned him his VC.

Sergeant-Major Pye was promoted ensign on 2 July 1858, then lieutenant when the regiment returned to England in 1861, serving as adjutant in 1861–62. After leaving the army in 1862, he and his wife emigrated to New Zealand where he served in the Maori Wars in 1860–66, and was commissioned captain in the Colonial Defence Force (New Zealand Militia). Charles Pye died, aged fifty-six, on 14 July 1876 while visiting relatives in Victoria, Australia. He was buried in the Tower Hill cemetery near Warrnambool.

*

Private Harold Edward Whitfield VC was born in Oswestry in June 1886, enlisting in the Shropshire Yeomanry in 1908. Mobilised at the outbreak of the First World War in August 1914, Whitfield left Shropshire four days later, expecting to be sent overseas, instead serving the next two years as part of the English East Coast Defence Forces. On 3 March 1916 the Yeomanry sailed for Egypt, amalgamating with other units to form the 74th Yeomanry ('Broken Spur') Division. At the Battle of Tell 'Asur on 7 March, the 10th Kings Shropshire Light Infantry succeeded in taking Turkish positions at Selwad. Three days later Whitfield's unit seized the hill of Burj-el-Lisaneh to their north. During the first and heaviest of three counter-attacks on the position his battalion had just captured, Private Whitfield single-handedly charged and captured the Lewis gun harassing his company at short range, bayoneting and shooting the entire gun crew. He then turned the gun on the enemy, driving them back with heavy casualties. When the Turks established an advanced position close to the British lines from where they were able to fire volleys of gunfire on his company, Whitfield organised and led a successful bombing attack that drove the enemy back with great losses, in doing so saving many lives as well as ensuring the defeat of the counter-attack.

Whitfield was promoted to lance corporal on 7 May 1918, then on 10 May 1918 to sergeant, receiving his VC from George V in Leeds on 31 May 1918.

He was killed in a tragic road accident at the age of seventy in December 1956, his car colliding with a British Army vehicle while he was on his way home from work. He is buried in Oswestry. Sergeant Whitfield's VC, plus his other medals, rifle and bayonet used in winning his VC, plus other personal possessions, are housed in the Shropshire Regimental Museum in Shrewsbury Castle.

*

Above: German anti-tank rifle, Tankgewehr, 1918. (Courtesy of Shropshire Regimental Museum)

Below: German Maxim 08 Spandau machine gun. (Courtesy of Shropshire Regimental Museum)

Acting Sergeant George Harold Eardley VC, MM, was born 6 May 1912 in Congleton, enlisting in the Territorial Army on 29 March 1940, posted to Guildford to join the Queen's Royal Regiment (West Surreys), serving as Acting (Unpaid) Lance Corporal, then as Paid Acting Corporal on 23 December. He transferred as corporal to the 4th Kings Shropshire Light Infantry on 30 July 1944, and was promoted to sergeant on 11 December 1944.

George Eardley won his Military Medal in August 1944 during fighting at the village of Le Beny Bocage, when he stalked and destroyed a German machine-gun post. In an odd twist, Eardley was awarded two Military Medals, one awarded separately and the other presented with his VC when he was invested by the king at Buckingham Palace in February 1945. One of his two MMs is housed in the Ashford collection, along with his original medal group. The other is on display in the Shropshire Regimental Museum in Shrewsbury Castle.

The Battle of Overloon, Netherlands, began 30 September 1944 – one of the fiercest in the war. After days of intensive fighting the Germans were pushed out of the village but regrouped in woods between Overloon and Venray. A platoon of the KSLI was ordered to attack the woods and drive out the Germans; however strong opposition from well-sited defensive positions manned by German paratroopers well equipped with machine guns halted progress around 80 yards from the objective. Firepower was so intense that it was suicidal for any soldier to expose himself to it without being shot. Ignoring the danger, Sergeant Eardley moved forward. He had spied one machine-gun post, and firing his Sten gun, destroyed the German post with a well-placed grenade. Spotting a second machine-gun post beyond the first, Sergeant Eardley ignored the German bullets and charged across 30 yards of open ground and killed the enemy gunners. Eardley's platoon continued the attack but was stopped by a third machine-gun post. A squad was sent forward but they were forced back with four casualties. Ordering his men to lie down, Sergeant Eardley crawled close enough to toss a grenade into the machine-gun nest, killing the gunners. Sergeant Eardley's single-handed destruction of the three machine-gun posts, carried out under the most intense fire, ensured the success of the whole attack.

Eardley was presented with the VC ribbon in the field by Field Marshal Montgomery. The VC medal itself was presented by the king at Buckingham Palace.

On 25 June 1964 Eardley's wife was killed tragically when their car was hit by an express train on a level crossing at Nantwich while on the way to a ceremony at Copthorne Barracks, where the Princess Royal was to present new colours to the 4th Kings Shropshire Light Infantry. George Eardley lost the lower part of his left leg, amputated at the scene of the crash without anaesthetic. He later remarried, but died only a few weeks later on 11 September 1991, aged seventy-nine. He was cremated in Macclesfield.

A replica set of George Eardley's medals are on show in the Shropshire Regimental Museum. A life-sized bronze statue of war hero George Eardley, in battledress and complete with Sten gun and grenade and a was erected in Congleton in 2004.

*

Private James Stokes VC was born in Glasgow on 6 February 1915, enlisting in the Royal Artillery on 20 July 1940, serving with the Royal Army Service Corps (52 Drivers'

John and Kate Shipley at a First World War battle site, Belgium. (Courtesy of John and Liz Merrifield)

Training Unit), before transferring to the Gloucester Regiment in October 1943. While on leave in 1944, he was sentenced to three years in prison for grievous bodily harm or be released into the infantry. He joined the Royal Warwicks, then transferred to the 2nd/ Kings Shropshire Light Infantry in October 1944. The battalion was then part of 185th Infantry Brigade at Overloon in Holland, with a Royal Warwicks Battalion serving in the same brigade, which might explain Stokes' transfer at this time.

On 1st March 1945 during the attack on Kervenheim, Holland, Private Stokes' platoon was pinned down by heavy rifle and machine-gun fire from a farm building. The commander of the platoon was reorganising his men when without warning and with no orders Private Stokes rose up and raced towards the enemy. Ignoring the German bullets and firing from the hip, he disappeared inside the farm building. Suddenly the firing ceased, and Private Stokes reappeared herding twelve German prisoners. Stokes sustained a neck wound but refused an order to go to the first-aid post. The platoon continued their advance, but nearing the second objective, heavy fire from a house halted progress. Once again, without waiting for orders, Private Stokes rushed forward, firing from the hip, until a German bullet felled him, but in a split-second he was back on his feet, rifle in hand, moving toward the enemy, despite coming under intense fire. Reaching the house, he entered and as before all firing ceased. This time he captured five more prisoners. Stokes was now seriously wounded and losing a lot of blood, but before the company could form up for a final assault on the group of buildings that was their next objective, Private Stokes, again without waiting for orders, dashed forward, attempting to cross the 60 yards to the buildings, all the time firing from the hip as he struggled through intense

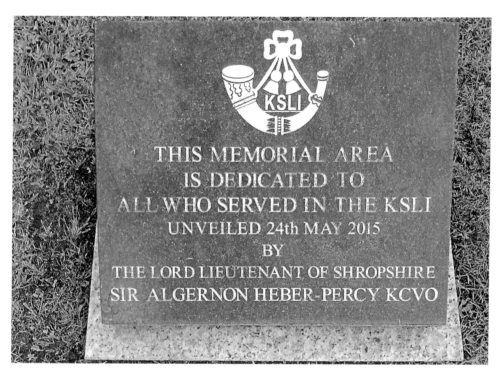

KSLI memorial plaque, National Memorial Arboretum NMA, Alrewas, Staffordshire. (Courtesy of the NMA)

German fire. This time he was brought down 20 yards from the enemy's position, still firing his rifle. Reports say that as the company passed him in the final charge, he raised a hand and shouted goodbye. He was later found to have suffered eight separate wounds in the upper part of his body. Private Stokes' magnificent courage and devotion to duty was an inspiring example to all, ensuring the success of the attack, his self-sacrifice saving many lives.

Private Stokes is buried in the Reichswald Cemetery in Germany. His VC was presented to his widow and son by George VI at Buckingham Palace. Stokes' VC and his other medals were sold by Sothebys on 21 October 1982 for £18,000, purchased by a private collector.

<div align="center">*</div>

Able Seaman William Charles Williams VC. Although raised in Chepstow, Williams was born at Stanton Lacy, near Ludlow, on 15 September 1880. In 1895, he joined the Boys Service at Portsmouth, promoted boys first class, then able seaman in 1901, joining the Royal Navy until leaving the service in 1910. He was a member of the Royal Naval Reserve while working as a policeman, and in a steelworks. When the First World War broke out he rejoined the Royal Navy.

Just after 6 a.m. on 25 April 1915, HMS *River Clyde*, an old collier converted to a troop carrier, grounded its port bow on the barbed-wire-strewn 'V' beach at Seddul Bahr, Cape Helles, Gallipoli. Sections of the ship's side had been cut away from which sloping gangways, suspended by wire hawsers, were run out, leading to a floating bridge of

barges secured to the ship in the event that the ship grounded too far from the beach. Packed into five rows of five boats were soldiers of the Dublin Fusiliers, whose role was to provide cover while the troops disembarked. Unfortunately the Fusiliers leapt from the boats into an entanglement of barbed wire and many of them and their boat crews were shot. The floating barge-bridge came up short of the beach, the gap too wide to cross, leaving many soldiers sitting ducks. Scores were shot by the Turkish defenders as they stood helpless on the uncompleted bridge. The commander of the *River Clyde,* Edward Unwin RN, together with Able Seaman William Williams took action without delay. Dropping from the ship's side, the two men waded through deep water to secure a line to a drifting boat, which they then towed towards a jutting spit of rock, intending to bridge the gap between bridge and beach. Meanwhile Midshipman Drewry attempted to wade ashore to secure the towing rope, but on discovering that the rope they had was not long enough, he returned to the ship for a longer rope. For over an hour Unwin and Williams waited for his return in chest-high water. Eventually the Turks found the range and Williams was shot and wounded, and then killed by an exploding shell. Commander Unwin carried Williams back to the ship but the sailor was already dead. Midshipman Drewry returned with the rope and the boat was made fast, enabling the waiting troops to finally cross the floating barge-bridge. The heavy enemy fire continued, and when a shell severed the rope the boats drifted out of position. Despite receiving a shrapnel wound to the head Midshipman Drewry swam to another boat holding a line in his teeth, but again the rope was too short. Midshipman Malleson then dropped over the ship's side with a longer rope and lashed the boats together. However, the rope snapped for a third time. Malleson made two more unsuccessful attempts to connect the barges. In the end the bravery of these men enabled the beachhead to be eventually established.

German U-boat gun memorial to the memory of William Charles Williams VC, Chepstow. (Courtesy of Peter Shipley)

Six Victoria Crosses were awarded to the brave sailors from HMS *River Clyde*: Commander Edward Unwin (aged fifty-one), Midshipmen George Drewry RNR (twenty) and Wilfred Malleson (eighteen), Able Seaman William Williams (thirty-four), Seaman George Samson (twenty-six) and Sub-Lieutenant Arthur Tisdall (twenty-four) of the Royal Naval Division (RND).

A painting of the Gallipoli action by the artist Charles Dixon hangs in St Mary's Church, Chepstow, one of two memorials to Able Seaman William Williams. The second is a naval gun from the German submarine SM *UB-91,* which was presented by George V and stands proudly in the town's main square adjacent to the town's war memorial.

<p align="center">*</p>

Thomas Orde Lawder Wilkinson VC was born in Dudmaston, near Bridgnorth, in 1894. Wilkinson was educated at Wellington College. In 1912, the Wilkinson family emigrated to Canada.

When the First World War began, Wilkinson enlisted in the 16th Battalion, Canadian Scottish, Canadian Expeditionary Force, later travelling to Britain, joining the 7th Battalion, Loyal North Lancashire Regiment.

On the morning of the 5 July 1916, during a British attack on German trenches defending the village of La Boisselle, a separate unit was forced to retreat, abandoning its machine gun. Lieutenant Wilkinson, with two of his men, rushed forward, got the machine gun working and set up a rate of fire that held the advancing Germans at bay until subsequently relieved. Later the same day the British advance stalled under a German bombing attack, and again Wilkinson advanced, locating five soldiers who

Anglo-French war memorial at Thiepval.

were taking cover behind a wall of earth over which the Germans were lobbing grenades. Wilkinson mounted a machine gun on top of the parapet and opened fire, forcing the Germans to retreat. Brave Wilkinson was later killed while making the second of two attempts to bring in a wounded man from no man's land. He died instantly, shot through the heart moments before he could reach the soldier. Unfortunately his body was not able to be recovered.

Wilkinson's bravery is commemorated on the Thiepval Memorial to the Missing on the Somme, which records the names of over 72,000 men killed on the Somme and who have no known grave. His Victoria Cross is displayed at the Imperial War Museum, London.

*

Lieutenant (Acting Captain) John Henry Cound Brunt VC, MC, was born on 6 December 1922 in Priest Weston, Shropshire. In 1934 his family moved to Paddock Wood. In 1941 Brunt joined the Queen's Own Royal West Kent Regiment as a private straight from school. He was commissioned 2nd Lieutenant in the Sherwood Foresters on 2 January 1943, but served with the Lincolnshire Regiment, landing in Italy at Salerno on 9 September 1943. He was awarded the Military Cross and the Victoria Cross for conspicuous bravery in the face of the enemy. He died on Sunday 10 December 1944 when a stray mortar shell landed at his feet and exploded.

*

Two ex-pupils of Shrewsbury School have won the Victoria Cross:

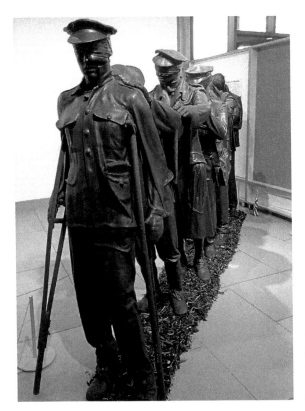

Victory Over Blindness sculpture by Johanna Domke-Guyot, commemorating those who lost their sight in the First World War. (Courtesy of Johanna Domke-Guyot)

Thomas Tannatt Pryce VC, MC and Bar was born on 17 January 1886 at The Hague, Holland, although his family was from Montgomeryshire. Educated at Shrewsbury School, he served originally in the Gloucester Regiment, transferring to the Grenadier Guards as Acting Captain in the 4th Battalion. Pryce was awarded the Victoria Cross following the action at Vieux-Berquin in France on 11 April 1918, when he commanded two platoons during a successful attack on a village. The next day, Captain Pryce and his remaining forty men repelled four German attacks during the day, but by evening the enemy had advanced to within 60 yards of the British trench. Captain Pryce led a bayonet charge, suffering heavy casualties, driving the Germans back some 100 yards. Now with only seventeen men left and out of ammunition, when the Germans attacked again, Pryce led another bayonet charge against overwhelming odds. He was last seen in the midst of fierce hand-to-hand fighting. His Victoria Cross is displayed at Regimental Headquarters of The Guards (Grenadier Guards RHQ) in London. Thomas Pryce's name is recorded on the Ploegsteert Memorial to the Missing.

*

Harold Ackroyd VC, MC, was born on 18 July 1877 in Southport. He was educated at Shrewsbury School, where he was a member of the Officers' Training Corps. After leaving the University of Cambridge, he worked at Guy's Hospital in London and other hospitals, before returning to the University of Cambridge to become a research scholar at Downing College. Ackroyd joined up early in 1915, commissioned as a temporary lieutenant in

The interior of Shropshire Regimental Museum. (Courtesy of Shropshire Regimental Museum)

the Royal Army Medical Corps on 15 February 1915, attached to the 6th Battalion, Royal Berkshire Regiment, part of the 53rd Infantry Brigade, 18th Division.

The Battle of Passchendaele began on 31 July 1917, and the 18th Division was involved in a huge military blunder. British troops of the 30th Division mistakenly attacked British-occupied Chateau Wood, instead of Glencourse Wood occupied by the Germans, the one Ackroyd's 53rd Brigade plunged into with fatal consequences. For the rest of that day, and the next, the 53rd Brigade attempted to dislodge a well-defended German position.

Totally regardless of danger, Captain Ackroyd worked devotedly for many hours up and down and in front of the British line tending the wounded, in the process saving many lives while frequently crossing open ground under heavy machine-gun, rifle and shellfire, carrying the wounded to safety.

Harold Ackroyd died on 11 August 1917 in Jargon Trench on the western edge of Glencorse Wood, shot in the head by a sniper. His body was evacuated and buried in Birr Cross Roads Cemetery, near Ypres. His headstone reads, 'Believed to be buried in this cemetery.'

For his bravery at Passchendaele Captain Ackroyd received twenty-three separate VC recommendations.

<div align="center">*</div>

Two other VCs are mentioned in the KSLI Regimental Museum in Shrewsbury Castle. Captain Godfrey Meynell VC, MC, of the 2nd/12th Frontier Force Regiment, Indian Army Corps of Guides (ex 1/KSLI), was awarded a posthumous VC for the action in the Mohmand Campaign on 29 September 1935.

Acting Assistant Commissar James Langby Dalton VC, London-born, enlisted in the 85th Regiment in November 1849, subsequently transferring to the Commissariat Corps in 1862. He was awarded the VC for the action at Rorke's Drift, Natal, 22/23 January 1879, during the Anglo-Zulu War. Dalton died on 7 January 1887 at Port Elizabeth, South Africa.

All are courageous men who hopefully will never be forgotten.

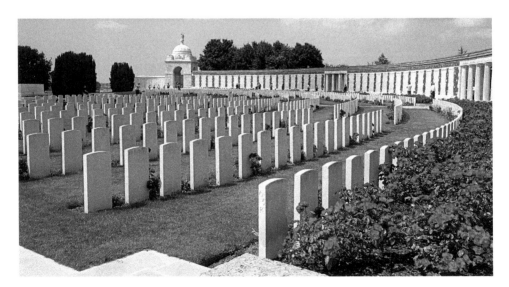

Tyne Cot Cemetery, Zonnebeke, Belgium.

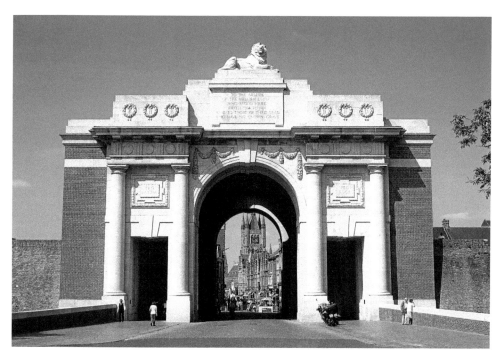

Above: The Menin Gate, Leper (Ypres), Belgium.

Below: KSLI memorial tableau, National Memorial Arboretum NMA, Alrewas, Staffordshire. (Courtesy of the NMA)

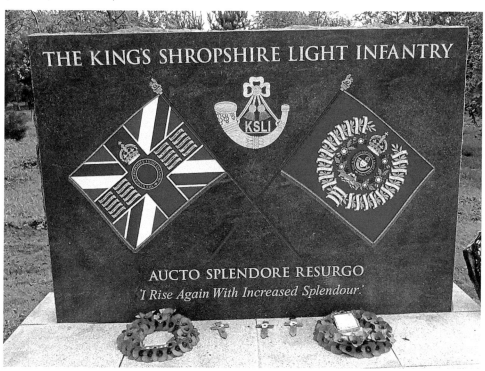

Acknowledgements

I would like to take this opportunity to publicly thank and acknowledge all the people, individuals and organisations that have helped with the compilation of material for this book, without whom the project could not have been completed:

Curator Christine Bernáth and the staff and volunteers at the Shropshire Regimental Museum, a huge thank you for allowing me to photograph the museum's exhibits and reproduce the pictures in this book; Adrian Pearce of the Shropshire History website (www.shropshirehistory.com); the staff at Shropshire Archives and Bridgnorth Public Library; BBC Shropshire and all local history groups and societies; and Tom Laporte, Winnipeg, Canada.

I must also pay tribute to J. R. B. Moulsdale for his work on the Shropshire regiments, and to Peter Druckers, the previous curator of Shropshire Regimental Museum, and to all writers who have contributed work on this subject.

To my long-suffering, proofreading wife Kate, and my son Peter Shipley, for their immense contribution: rewrites, additional facts, and proof-checking. To Naomi Holdstock, Tricia Bennett, and John and Liz Merrifield for their photographs, plus my good friends Eric Smith and Mike Thomas for their input. And finally to Alan Murphy, Commissioning Editor, and Team Editor Jenny Stephens and all at Amberley Publishing.

The material for this book has been compiled and assembled from personal research, archive material, various websites and printed matter, and of course word of mouth, all of which has been used in good faith.

And lastly, please forgive me if I have not included any of your particular favourite items.

The author with grandsons Harry and Jack.